Roberto Capucci. *Timeless creativity*

Roberto Capucci
Timeless creativity

Edited by
Gianluca Bauzano

Cover
Cinabro, detail
Dress designed for Venice Biennale, XLVI
International Art Exhibition

Back cover
Portrait of Roberto Capucci
Photograph by Tony Thorimbert

Graphic design
Marcello Francone

Editing and layout
Claudio Nasso, Serena Parini

Translation from Italian
Timothy Stroud

Illustrative materials researcher
Capucci Historical Archive
Serena Angelini

The first edition of this book was published on the occasion of the exhibition Roberto Capucci. Creatività al di là del tempo, *Venice, February 13-27, 2001.*

The author would like to thank

Roberto Capucci

Marcella Capucci
Enrico Minio
Serena Angelini

Yvonne Capuano, Rita Frisciotti and the staff of the Capucci Historical Archive

Cavalier Mario Boselli

Carlo Bertelli
Antonio Mancinelli
Guido Vergani

Marco Delfini

Camera Nazionale della Moda Italiana
EMI Classics

The photographers and illustrators to whom we are greatly indebted for the kind contribution of their work to the catalogue and exhibition are:

Giacomo Artale
Stefano Canulli
Gianmarco Chieregato
Arrigo Coppitz
Angelo Del Canale
Angelo Frontoni
Uberto Gasche
Cristina Ghergo
Johann Kräftner
Mino La Franca
Gianfranco Lely
Massimo Listri
Fiorenzo Niccoli
Giorgio Penati
Rubino Rubini
Sette-Corsera Arch. Fotografico
Tony Thorimbert
Amedeo Volpe

In addition:
Studio Foto Bertazzini
Studio Foto Gilbert
Johnny Moncada
Norman Parkinson
Regina Relang
Renata Rieder
Studio Foto Sharland
G.R. Somerville

And for their help:
Stefano Babic
Giovanni Gastel
Pino Guidolotti

For their permission to publish their portraits, thanks are due to:
Princess Jeanne Colonna
Valentina Cortese
Raina Kabaivanska
Rita Levi Montalcini
Virna Lisi
Donna Marisa Nasi Coop Diatto

The publisher and the curator are happy to hear from anyone unwittingly missing from the list of credits

What has made Roberto Capucci unique right from the start of his career as a clothes designer is the timelessness of his intuition: a timelessness that has allowed him, and still does, to create textile constructions of such powerful artistry that they exist outside of the defined spaces and times linked to the frenetic succession of the fashions and mores of modern society.

A great number of exhibitions have been dedicated to the work of Roberto Capucci and he has been invited to display his creations in famous museums and in joint shows that have assembled great talents of the twentieth century. Every exhibition showed up the power of his work and the solemnity of his designs that are even more vital, strong and perceptive than is apparent at first, distracted glance. This power is so vigorous, it is as though it were permanently in a sort of corridor that traverses time and, consequently, seems not only contemporary but also avant-garde.

The audio-visual route proposed in this exhibition is intended to emphasise exactly that contemporaneousness-timelessness that characterises the art of Roberto Capucci. It is not so much a chronological or anthological path but more of a journey into the universe that Capucci inhabits and into his creativity that is bound neither temporally nor physically. This route makes use of the most sophisticated audio-visual systems and structures available used in exhibitions of international contemporary and avant-garde art.

These are modules that seemingly have a life of their own—wundekammer of the twenty first century—and project films, slides and mosaics of images that bring home the power of Capucci's creative genius to the visitor who is new to the Roman designer's work. Capucci is a genius that can even co-exist happily with the artifice of the Baroque, for example, created in the exhibition as though on a large stage of pure illusion, in which one, none or one hundred thousand face-masks are used to create a homage to the timeless beauty of women as represented by famous women of the past: Cleopatra, Elizabeth I, Isadora Duncan and Maria Callas have all been "reinvented" wearing creations designed by Capucci.

But the genius of Roberto Capucci also comprises pure form and a magical fusion of esprit de géométrie and esprit de finesse. The tricks played by the audio-visual system allow clothes designed nearly half a century ago to be viewed perfectly integrated into classical and avant-garde architectural settings.

Nature and colour have always formed another of the cardinal principles of Capucci's art. Like ocean waves are a demonstration of the power of the wind, the sculptural creations exhibited do not so much show their source of inspiration as underline how they are a materialisation of the forces around them, and the result of the primordial elements of air, water, earth and fire. In addition, the explosion of liberated forms fosters a clever use of colour based on the geometrical construction of the clothes developed from perfect preparatory drawings. They are like a gigantic fresco of vivid colours enclosed in a casket.

The most recent creation of the Roman designer has been sculpted using one of the most advanced technological materials available, the ultra light hollow fibre called Meryl Nexten. And like the sublime experimenter he has always been, Capucci accepted the request to create a new sculpture using this material just for this exhibition. It is yet another hymn to the beauty of which this designer has always been a devoted follower. The colour of the joys of living and creating explodes as though from a shattered architectural structure in confirmation that the creativity of Roberto Capucci cannot but stand outside of time, now and always.

Gianluca Bauzano

Contents

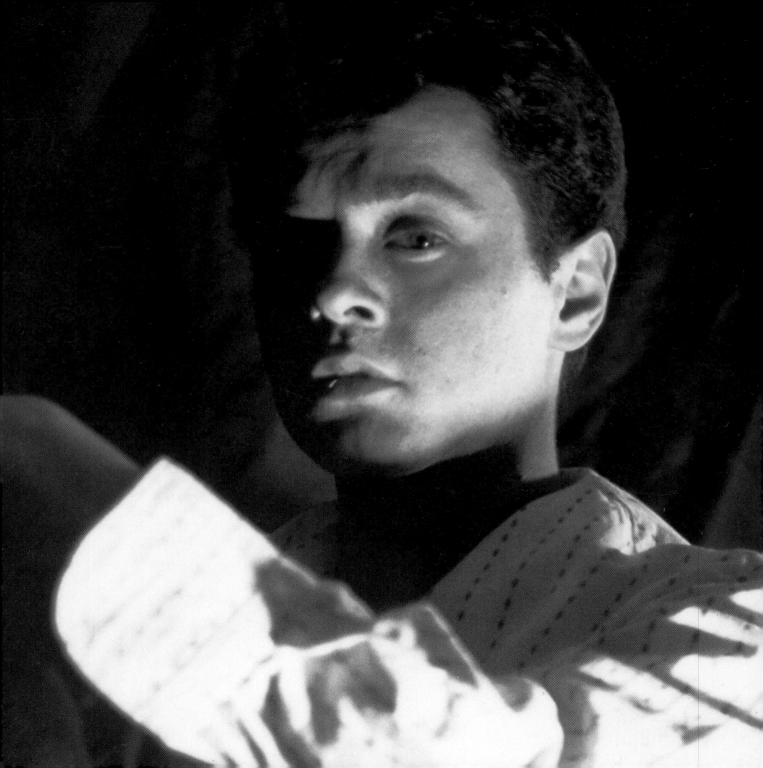

A Dress? A Habitat of Fabrics

The closest female followers of fashion have spoken of Roberto Capucci as removing clothes from the "tyranny of the body," of the body being made geometric and "only used as a support for his works." The opposite, apparently, of the lines, cuts and forms used to exalt the body. But perhaps one should use the eyes of a man to look at Capucci's clothes, at his "fans," his "overlays," his "petals" and his Baroque triumphs to understand the extent to which the creativity of this designer has not been distanced from an amorous idea of the female body. Capucci considers a dress "a habitat of fabrics, an ornate form and a cave to live in." This is the least abstract concept of fashion possible because designing a "habitat" presupposes having a deep knowledge of the person who must live there, of her way of moving and living. "I create for women, not for mannequins," said Capucci. "This reputation for abstractness, lines and forms for their own sake is one I have always had to live with. At the end of the 1950's, I designed square lines and box forms. These are repeatedly turning up in my work. At the time it was a huge risk, it was the period of the '*jolie madame*', all soft and feminine. I was accused of having put femininity in a coffin but in New York I was awarded the Oscar of the fashion world. That collection sold enormously well, which was a sign that women did not feel that they were being buried. Year after year, I used the inspiration I found in nature, sculpture, architecture, the Roman Baroque, the shade and light on certain gables or volutes and put it into my work. In order to do so more freely, I tried not to be caged in by the obsession with the body, by the dictates of a fashion that was obliged to emphasise or hide. I tried to give each dress its independence from the body, which does not mean going against the body; it means not limiting femininity to the shape of the body. It means perhaps duplicating, exaggerating the lines of the body's movement in the dress."

Capucci's idea of women is so full of affection and respect that he is filled with indignation at "the sloppiness, the vulgarity, the showiness, the Folies Bergères" of modern fashion. His opinion is very severe and professionally aristocratic. "Dressing is a ritual, a piece of magic. A woman cannot be reduced to the level of a showgirl. For many designers, clothes have to be sexy, young and fashionable. If I could, I would ban the word 'fashion' from the language. To be 'in fashion' is already to be unfashionable and outmoded simply because it becomes a mass phenomenon. The idea of being 'youthful' once past thirty years of age makes me shudder. As for sexiness, the way it is done now is simply to place the emphasis on the bust and behind. I feel rather like a survivor from the past, I, who worship beauty and idealise women, and I wonder what sense there is in persisting: sixty two metres of fabric and three months of work to create a single dress, triple organza for certain

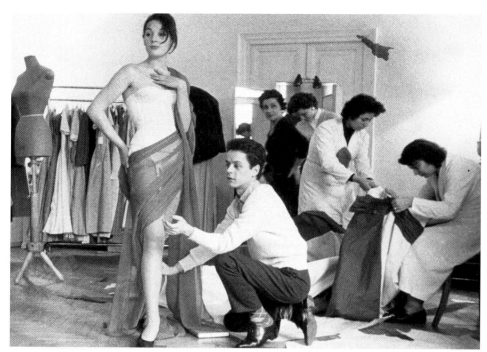

1951, Rome.
Capucci at work
(Capucci Historical Archive).

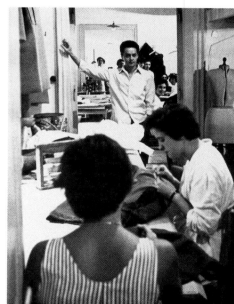

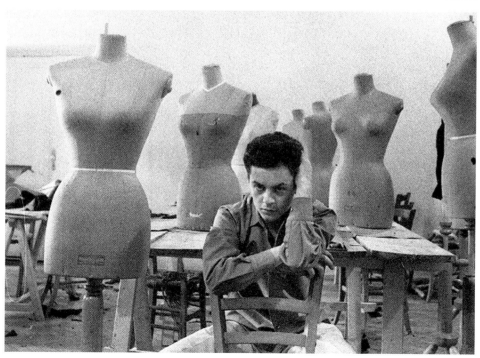

volumes, all hand-stitched? Yet I continue and, in doing so, I put myself at risk." He continues because "this work has taken violent hold of me, it has affected my entire life and has had a strong influence on my private life. When I design, I am freed of all my fears and there are moments when I feel as if I have been drugged with the joy of creativity." He says he does not work to fixed hours and may find himself working at dawn on a design. For each collection, he makes 1200 to 1300 sketches. He calls them "drawings of beauty" and it is clear they are not simple outlines. He says that as a child he filled exercise books with drawings: just shoes, those orthopaedic ones that were around during the war because "perhaps it was their ugliness that fascinated me." Then, when he was a student at art school, he drew only skirts, thousands of skirts. Without knowing it, he was drawing his future. "Those drawings of mine were seen by Maria Foschini, a journalist. It was she who convinced me to open a dressmaker's shop. I did it almost in secret because my mother was against the idea. I took an attic in Via Sistina in Rome and employed a cutter and two workers. I began with a cloak for my

cousin. It brought me luck. It was 1950. Thanks to Giovan Battista Giorgini, Italian fashion began to raise its head in the shows in Florence. "Bista," as he was called, invited me to join in. No display on the catwalk as I was the last to join and the established designers would have been offended. It was July 1951. I was supposed to present thirty dresses as a surprise during the ball that closed the shows in Florence but the big names got to hear of it and vetoed my display. It turned out in my favour however because the next day the photographers and journalists rushed down to Giorgini's house (who had not abandoned me) where he had asked me to exhibit them. I was twenty years old. I have never forgotten Giorgini, the protection he offered and what he said to the young boy that I was: his advice was to work without letting myself be conditioned by the need to make my designs commercially attractive or to feel the need to be fashionable. In short, that was the advice I followed when I turned my back on the fashion system and decided to exhibit my clothes only when and where I want, only when I feel I am ready, without having to bow down to the dictates of the seasonal collections. It was like being reborn."

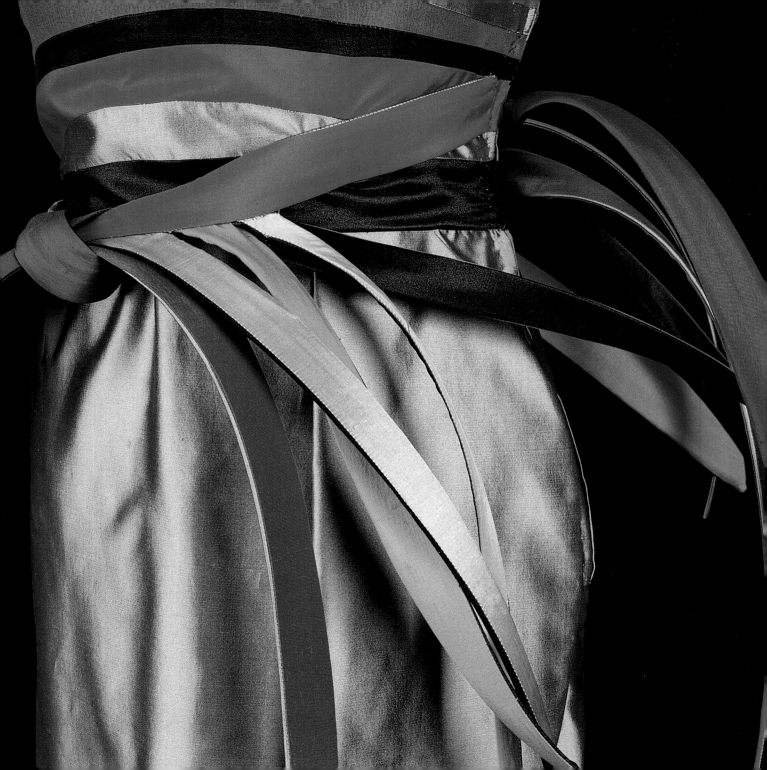

Gianluca Bauzano

Roberto Capucci:
An Experimenter Outside of Time

"If what you do or believe does not please the crowds, try to delight the few. It is a mistake to want to please everyone."
(Friedrich Schiller)

Experimentation is a necessary aspect of an artist. And if the experimentation inherently contains the revolutionary seed of the desire to go beyond the limits, the act is never done as an end in itself. On the contrary, it is a functional part of creation, experimentation-defiance made to give life to atemporal forms, never for the simple desire to astonish the public for a few instants as often happens in the ephemeral passage of the fashions and mores of the moment. Artists have always been eccentric, that is to say, outside the bounds represented by the commonplace, so far outside that they can spark paradoxes that bring life to their works. If they were not like that, they would not be artists. In the half century of professional work since Roberto Capucci's appearance on the Italian fashion scene in 1951, he has only ever behaved as an artist—in the full sense of the word—could have done: by experimenting, breaking rules, running away from the static centricity of the banal and trite.

The criticisms sparked off by a fringe group of critics and art experts who have been unable to consider the *haute couture* designs of this tiny sculptor-elf on the same level as any other pure form of artistic expression, have in fact only confirmed over the past fifty years the purity of Capucci's pedigree as a creator of works of art. Typical of Capucci is the eccentric experimentation in forms and

materials that he uses to create what are now historically recognised as "sculptural dresses" that right from their first appearance have never been subject to the "commonplaces" of the fashion universe by which I mean the catwalk presentations with their modes, sense of transgression and ephemeral seasonal trends. In a continuous search for *stimuli* and animated by the sacred flame of experimentation, at times carried to an explosive burst of workmanship and development of forms, Capucci does not find his inspiration in art or in artists. He made this overwhelmingly clear in his 1993 Paris show "*Regards sur la Femme*" in which, Anna Coliva recounted, "His clothes are presented with works of some of the great artists of our century. I heard someone say that Capucci's clothes seemed to create their own dialogue with these other works: and to have said to the sculptures by Arp that they well understood that the biomorphism of the possible is a theme that should be played on eternally, or to the paintings by Balthus that even the forms of their silks are a sort of nudity, or that they were reflected in the sculptures by Germaine Richier as metamorphoses hidden in the folds and the stripping bare of real existence … Dialogues, not developments."
Capucci, in fact, does not develop or transform an existing concept. He creates, and the results he obtains reveal

*1992, Berlin, Schauspielhaus
(Photograph by Amedeo Volpe).*

17

similarities with other existing works rather than simply being a contemporary version of one or more of their elements. His suits with the optical effect created by the enmeshed black and white bands of satin produced in the winter 1960-1961 are not just suits that play on the contrast of two colours in a pattern derived from tartan: that contrast of black and white obtained using a material with powerful luminescent and chiaroscuro effects like satin is a concept so original that it could be compared to certain compositional devices by Vermeer, the master whose forte was the rendering in paint of light filtered through a window as it strikes objects in a room. Similarly, the flat surface of the woven satin bands animated by the light to the extent that they create effects of chiaroscuro provides sensations equal to those felt as one studies images of *The Concert* (stolen in 1990 from a museum in Boston). The Dutch painter chose a floor of black and white marble tiles to create the basic perspective of his homely scene, which were then struck by a shaft of light through a window.

Capucci's painstaking work is based on continual, spontaneous experimentation with materials. A few seasons after the optical effects mentioned above, it was the turn of architectural geometrical patterns created using plastic. The *lamé* dress with the trapezoidal overlay made from transparent plastic was created in 1966. This was a development of the "*Linea a scatola*" design for which he won the Fashion Oscar in 1958. The simplicity of that dress with the geometrical form has the solemn appearance of one of the many architectural ideals of Étienne-Louis Boullé: a *Projet de porte triomphale*, an expression of pure architectural form. Capucci is not a designer of geometrical or architectural forms. Clothes design is simply the field in which this master has developed his artistic abilities. The collections, shows, one-man and joint exhibitions over five decades are simply the markers that indicate the creative periods of this particular artist. As Franco Maria Ricci explains in the introduction to his monograph *Luxe, calme et volupté*, "We do not see the frenetic variations of *trends* in Capucci's work: instead there is a stylistic continuity that makes it very difficult to date one of his creations. If we can use the term 'fashion' speaking about others, for him we can at most refer to a 'school' as one does in the field of painting. Behind his designs there is a unique aesthetic continuity free from the influences of taste; there are those who get their inspiration one year from Egypt and the next year from Japan, but Capucci is always inspired by Capucci. As can be said of Titian, we can only speak of a young Capucci and a mature Capucci. As with parquetry, precious stones, works in glass or porcelain, his clothes astonish and ask to be touched. This is to say that Capucci, one of the very great clothes designers, does not belong to 'dress-making' but to art."

Moreover, his apprenticeship was not served in ateliers or workshops. He studied at art school and then moved on to the Academy of Fine Arts in Rome where his teachers were people like Mazzacurati, Avenali and Libero De Libero. These were fundamental experiences in his training. "He was a wonderful, fascinating man, and also generous" said Capucci remembering Mazzacurati. "I always got nine in

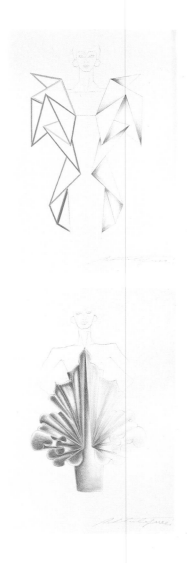

Original drawings by Capucci for dresses never made, below 1993 and 1989; right 1954 and 1977 (Capucci Historical Archive).

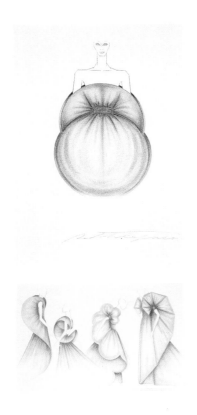

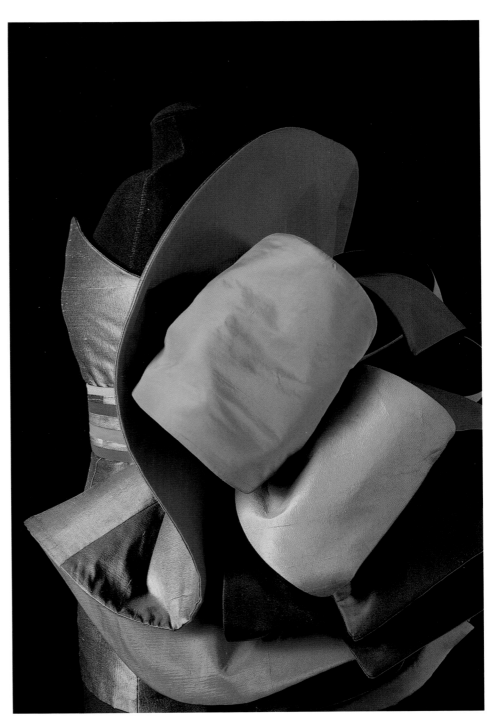

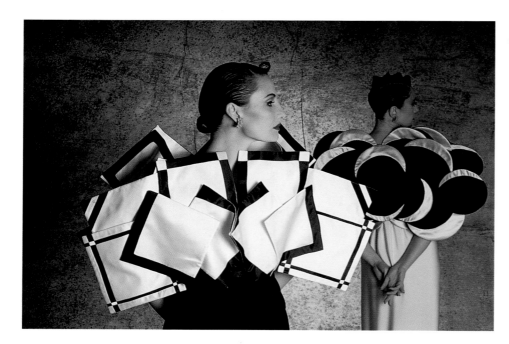

sculpture, I worked with clay, he made me want to." Capucci was fascinated by sculpture and its three dimensionality. "What could be more thrilling? The vibration of the various angles, the formation of the shadows, the folds, the different perspectives, the possibility of moving around it and getting new viewpoints." But instead of continuing the training that would have introduced him to the worlds of sculpture, painting, architecture and even set design and illustration, Capucci decided to devote himself to creation and, in particular, to the invention of women's clothes. Yes, invention. His first showing was in the 1951 Florence shows that set Italian fashion on its feet thanks to the stubbornness, generosity and intuition of Giovan Battista Giorgini, the brilliant aristocrat who, in trying to calm the novice Capucci down, reminded him that,

"You must always feel free to do what you want." And Capucci followed his advice to the letter. During his first ten years of work, while the names Schubert, Carosa, Fabiani and Simonetta were winning plaudits, Capucci did not so much design fashion like his famous colleagues did; he invented women's dresses. The inspiration for the 1956 *Dieci Gonne* came from "watching the rings on the water having throwing a stone in." This dress became an icon of the era and was chosen to be part of an advertising campaign for Cadillac cars and used in a comic strip based on Marilyn Monroe. From one invention to another: two years later came the disturbing *Linea a scatola* which was the direct expression of Capucci's philosophy: the creation of a "wrapping". "A dress is a place for a woman to live in," he explains, "to exalt her and turn her into an apparition." Capucci's dresses therefore are

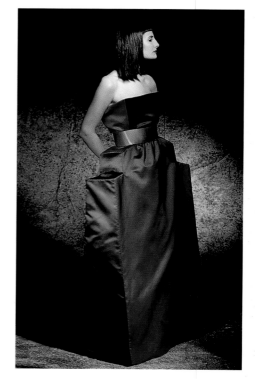

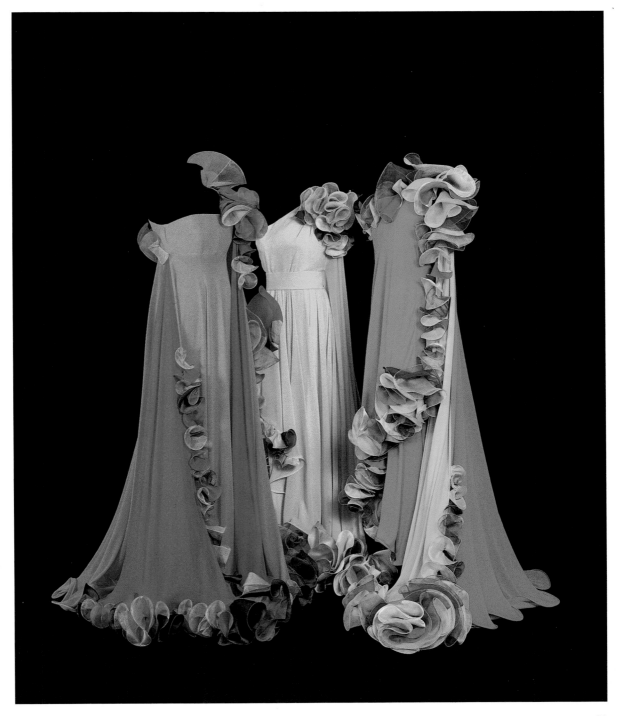

Fragments of creativity in plexiglas, taffeta and silk, 1967, 1989, 1992 (Photograph by Amedeo Volpe).

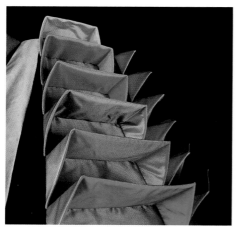
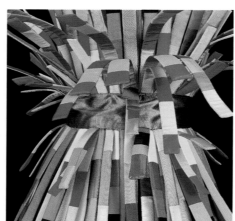

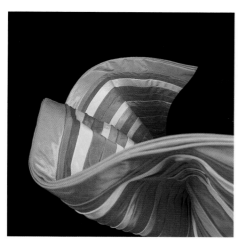
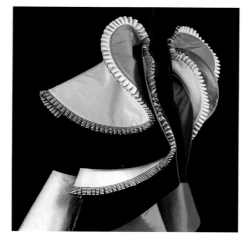

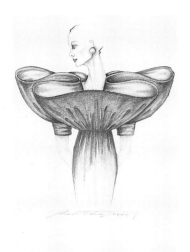

1985, New York, original drawing by Capucci and dress (Capucci Historical Archive; catwalk photograph).

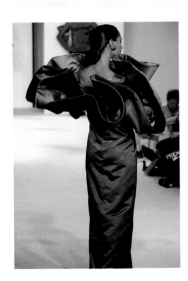

clothes that right from their initial conception transcend the notion of an item of clothing, even for the women who wear them. They are not simply customers but clients, increasingly wishing to own those unique articles. And the client, as we know, is the only person in perfect symbiosis with the artist. When it appeared, the *Linea a scatola* caused a scandal: it was not the umpteenth glorification of the female body crushed by a corset as dictated by Dior's *New Look*, but an abstract, rigid volume with four sides that drowned, denied the body. In reality, of course, it was not like that because the woman was wearing a pure form of art. From his beginnings, Capucci seemed already to confirm what Jean Clair was to say to him almost forty years later: when the then Director of the Visual Arts section of the Venice Art Biennale invited Capucci to take part as one of the twenty Italian artists in the centenary anniversary of the event, he said, "Bring the designs that are the maximum expression of your art," and he added shortly after, "And when creating them, never forget the work you do." Capucci stresses, "Clair reasserted the philosophy I have always held: that of remaining tied to the present and to the circumstances of my work but never forgetting where it came from or how it got started." That is exactly what happened in 1958 with the *Abito Scatola*. Capucci designed a line based on what was contemporary at that time and on a certain "stylism" expressed so well by names like Cardin and Courrèges, but he added a dash of pure invention to create an artistic "wrapping" for a woman. It was so original it won the Fashion Oscar, presented for the first time to an Italian designer. A comparison between Cardin, Courrèges and Capucci immediately reveals how the Roman master differs from the two French designers; a perfect analysis by the writer Patrick Mauriès stated, "In the work of the latter two, the geometry of the forms, the simplicity of the volumes and the rigidity of the materials laid claim most of all to being signs of modernity, of a fundamental economy (both graphically and materially), of an absence of encumbrances, of that new freedom that the Sixties announced, and of an imaginary world of the future. Thanks, above all, to their sense of proportions, to the emphasis placed on the body, and to how they altered its centre of gravity, the styles of both Courrèges and Cardin were an exemplary illustration of the referential changes taking place in the canons of fashion with the shift from the bodily proportions of a mature woman to those of a young one. None of this was true of Capucci whose reference standards remained unaltered. His is a universe of pure formality, of a contrast of volumes, of dynamic interrelationships in which the forms seemed to emerge by themselves. It was the box, the angles and the intersection of the surfaces that seemed to be the alternative, the crystalline and mineral reply to the convolutions of the organic models that so clearly inspired Capucci's experimentation."

Capucci never forgot his reference point: women. But they were not just women like any other; they were of an uncommon type, never anonymous. It was natural that his clients, the only ones who would be able to give a human face to those hieratic masks he used on his preparatory designs, were strong women with centuries-old

23

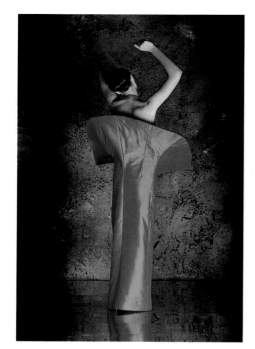

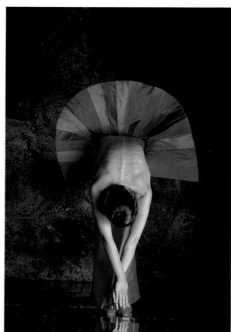

family trees and unusual and fascinating personalities. They all had in common a rare, unique beauty: sublime and evil-like, the kind of beauty that an actress like Silvana Mangano could reproduce. The first time Capucci dressed her was the only time he produced designs for the cinema, Pasolini's film *Teorema*. On this occasion too, the costumes were not simply a representation of a period and a class (the upper middle classes of the Seventies), they went beyond their immediate characteristics to become an "allegory of the present." However, the important aspect of this meeting was what Capucci saw in the actress, i.e. as Mauriès explained, "The ideal embodiment of femininity as he conceived it: carnal and ambiguous, elusive, unattainable, ever-changing, sensual yet also with a touch of abstraction, just a hint, like the shade of

blusher she used to contrast the paleness of her face," and he added "Mangano's face was frail and solemn, yet full of passion, as transparent and pure as a mask used in Japanese No theatre. Her face was the expression of extinguished passions, of composed gestures. Capucci wanted to interpret the actress's shyness and absent-minded attitude as a transfiguration of her sensuality, as if, after being the personification of eroticism in the film *Riso amaro*, she was at the point of annulling her corporeality, refusing to show herself by hiding behind her extreme, almost paralysing modesty."

Any woman knows that a dress by Capucci, though designed and made to fit a woman for a particular occasion, remains his conception. His feminine ideal was perfectly embodied by Silvana Mangano, but, in reality, the woman Capucci has in

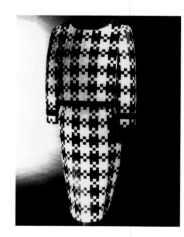

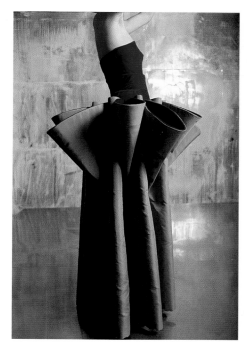

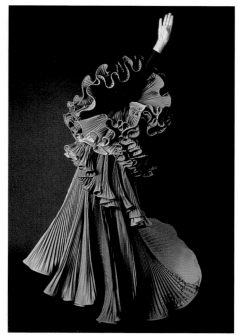

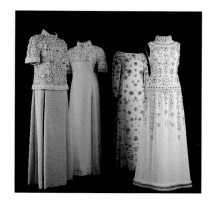

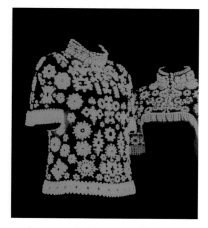

1965, Paris, Phosphorescent effects (Photograph by Amedeo Volpe).

mind as he conceives a dress is required to face a challenge: that of "inhabiting" the drawing (the fundamental creative moment of Capucci's art) but also of not being overwhelmed by the encounter with the forms, materials and the phantasmagoria of colours. She must be able to "carry" the dress, freeing it from the abstraction of its forms, in order to give it life and imbue Capucci's creativity with a living spirit. Capucci is never imprisoned by his geometrical shapes or arrangements of materials whether they be plastic, phosphorescent rosary beads, straw, aluminium, raffia, pebbles or metaphorical images of flowers or animals. He is a "master of Baroque wit and visual entertainment," he is never "conditioned or limited by practical requirements or by technical difficulties." The aim of his fashion is that every creation is unique, a

virtuoso invention, a work of art. The concepts of "fashion" and "work of art" blend, denying the apparent contradiction of the two terms. "The title of artist can be given to anyone who brings in new values, whatever means of expression they use: fabrics, goose feather or marble" as Giulio Macchi wrote when introducing the work Capucci created for the 1995 centenary edition of the Venice Arts Biennale. "In his atelier-cum-forge, Capucci uses a needle and thread on silk as if he were treating metal; he shapes the silk as if it were tin, and he smelts it like bronze. In one of the twelve sculptures created especially for the Biennale, the drapery of the silk gives endless shades of colours in the same way that mixing and ageing bronze does." Capucci's designs and creativity must not be considered from the simplistic point of view as dresses to be worn but for what

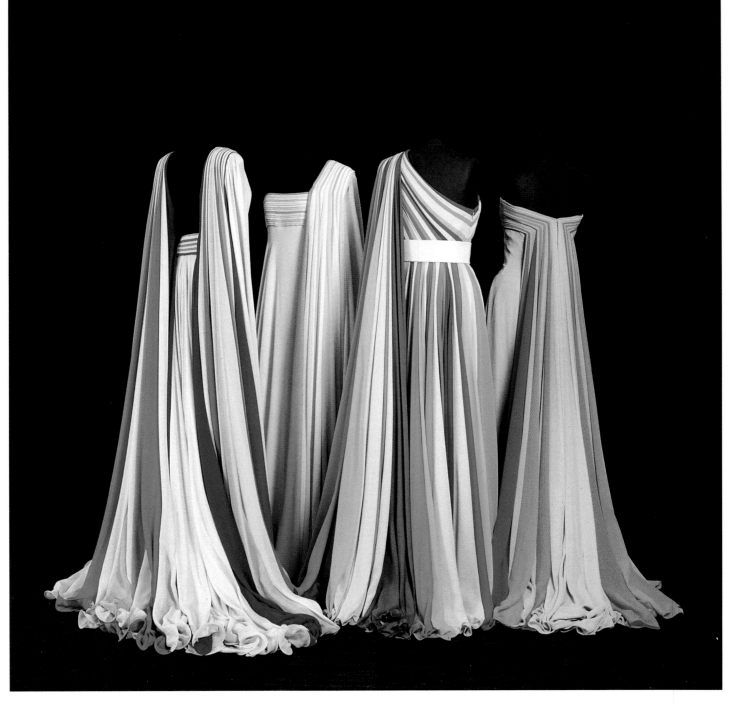

1970, Silvana Mangano in Teorema by Pier Paolo Pasolini (Capucci Historical Archive).

they really are, dresses invested with the interpretation of an artist, and therefore far removed from the insipid "purpose" of the object itself. Capucci's creations require the skill of a sculptor in the cutting of the fabric, the knowledge of an architect in the invention and construction of new forms, and the inspiration of the painter in the application of colour. Capucci is a master in combining colours, as Alvar Gonzáles-Palacios said, "The green of an emerald, the green of a new leaf, the green of the sea, the green of an apple, the green of a billiard table or a glass bottle, the green of undergrowth in the autumn or an almond tree in summer, green and green again, one on top of another, the second shade on the third, and the fourth emerging from the previous one, blending and integrating one another in a crescendo that suddenly drops like the ominous end of a melody. Hues of a particular shade brighten and fade like frames of a film follow one another; they exalt each other and in turn develop into an autonomous form, even in the stillness of all the surrounding forms. What creature is this? Is it alive or sleeping, dead or awake? Are they the lianas of a tree, neatly cut and realigned with the patience of a botanist? Or perhaps a flock of single-coloured butterflies magically frozen into immobility as they flew? Could they be a series of pure and impure colours chasing one other on the palette of a painter? The shape of a woman is revealed beneath the blends of shapes and layers of colours that they wish to frame, to stroke and to praise as if the ephemeral beauty of the fabrics was asked to comment on that other, equally ephemeral construction, the one made of flesh and bone."

Capucci's timelessness as an artist is the result of his solitariness as an individual; solitude is the only lifestyle that allows the artist to avoid rules and to leave him alone with his technique and his materials. Thus, he dominates them over time. This is why, when asked about his "splendid isolation," the artist answers by quoting Schiller's timeless phrase, "If what you do or believe does not please the crowds, try to delight the few. It is a mistake to want to please everyone."

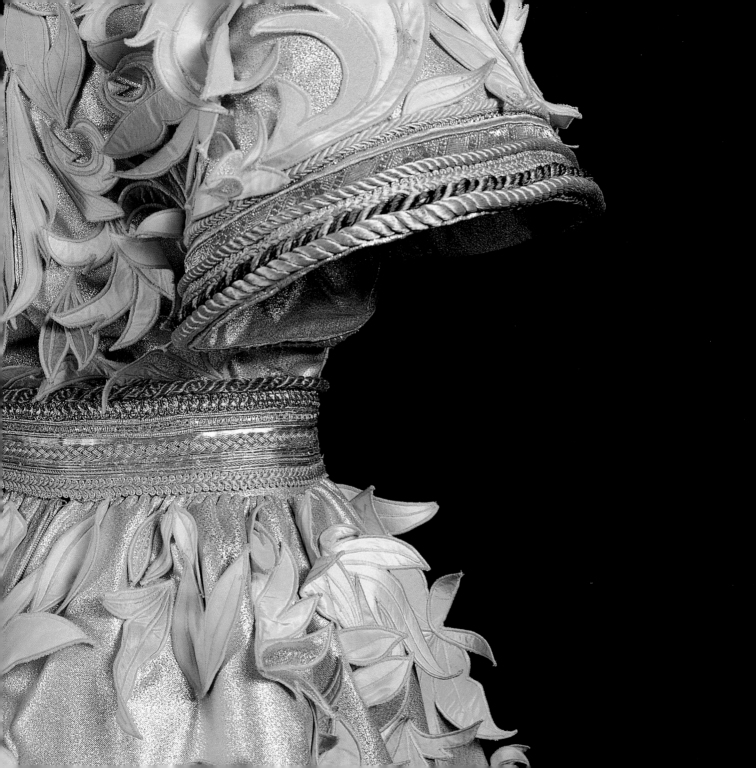

Antonio Mancinelli

The Dreams of Clothes

"A thing of beauty is a joy for ever."
(John Keats)

"There is an artist in every craftsman and a craftsman in every artist."
(William Morris)

1992, Berlin, Schauspielhaus
Detail
(Photograph by Amedeo Volpe).

Roberto Capucci belongs by right to the artistic and aesthetic category of great clothes designers-architects that includes, most importantly, Cristobal Balenciaga and Charles James, but also the Japanese like Issey Miyake, Rei Kawakubo for Comme des Garçons and Yohji Yamamoto and then heading right to the offshoots of the avant-garde fashion offered by those like the two young Dutchmen, Viktor & Rolf. And this should already explain why some, not particularly veiled, accusations of "anachronism" have no basis in fact as Capucci's standards and approach prevent him from conceiving his designs simply as vehicles for short-lived trends. His creations are more like studies of volumes, the dialectics of forms, the interactions between open and closed spaces, contrasts between lines and a jubilatory obsession of colours, structures and designer construction. His clothes are three dimensional ideas—let me repudiate another hackneyed accusation made against him—that do not deny the female body, do not hide it inside the magnificent fabrics of curved *plissé*, rigid wings, iridescent colours, joyous triangles, giddy spirals, exuberant circles, unimaginable flowers, whirling elytra, impossible petals and sensorial geometrical patterns orchestrated in such a festive, magnificent, impressive, Baroque yet well-considered, weighted, perhaps even severe dazzle: engineered in fact. No. Capucci

has always been well aware of the etymological root that links the word "habit" (as in clothes) to "habitat." Germano Celant wrote in *Interview* in 1991: "Since 1950 Roberto Capucci has continually amazed the world of Haute Couture with his architecture for the body. The clothes of this remarkable European designer are like sculptures. A historian would probably describe them like 'soft suits of armour' from the Middle Ages. A botanist might see them as giant corollas from which silk petals in oriental tones irradiate. A mathematician would undoubtedly comment on the dramatic geometric forms used in the design. Everyone who sees Capucci's clothes is agreed on the fact that they are fantastic habitats." And his clothes are designed to be lived in. They are not just ornaments for the female body, but with his consecration, they are magical, symbolic, in some way sacred, even untouchable, of divine inspiration and elevated to the rank of Mystery. Joyous Mystery, Glorious Mystery. Capucci's imagination, his love of a myth of Beauty that sometimes seems to us lost, is reproduced in a celebration of the senses—the echo of the rustle of taffeta, the elegy of tones of amber that still seem to give off their perfume, the sweetness of a thousand nuances that spread like circles in a pool—not of Narcissus but of Egeria—turn his creations into wearable architectures. The

fans, overlaps, Baroque sartorial "machinations" are unexpectedly not sterile and cold exercises in ability taken to the limit, but the greatest tribute to femininity that still encloses in itself the secret of Life, the question of existence, the answer to the possibility of finding Beauty in a world made sterile by violence, deadened by the lack of sensitivity, subjected by the sinister power of a global and globalising economy. Like protective constructions against the siege of everyday life, women's bodies are protected by Capucci's clothes and not obscured by them. On the contrary, the wearers of "a Capucci" are freed from the shadow of the predictability that kills the desire for surprise. The "Capuccine," as Capucci's faithful customers are referred to, enhance their bodies by protecting them in these caskets of fabric and art, thus defending themselves from banality. The flounces act as shields, the bodices as armour, the sleeves use embroidery as weapons, and the opulent skirts keep at bay their constant enemy: a poverty of intellect and creativity.

The sentimental geometry of fabrics and colours is no longer a dangerous virtuosity; today it is part of a feverish, lively and languidly labyrinthine frenzy. It is a drawing, captured in the air and set as a permanent snapshot, it is a hypothesis, a promise, a contagious spell that enchants and entices. Capucci's spirit of experimentation or inspiration—which, as will be mentioned later, is derived from the careful observation of landscapes that would not suggest much to the rest of us— explores, experiments, discovers and, finally, displays. Capucci's is a capricious spirit that does not follow trends and is not placated by the packaged half-yearly

collections; instead, it functions feverishly within the space of a dress, a combination of sartorial expertise and inspiration, a blend of knowledge and masterly skills, a fusion of professionalism and genius. The results are intensely alive, they provide us with enjoyment even when they are hung on mannequins in museums, and they enliven the display areas with their overwhelming, sensual fantasy that conjures up Nature in its wildest state and the soft colours of Mannerist painters. So rich, powerful and figurative, yet the cut is precise, sharp and daring: Capucci's creations are the symbols of the heraldry of Beauty, allegories flung into the spreading sea of the banal that whip up vortices of foam as soft as fantasy, though they can also raise indignation. They are the inventions of a designer who has a passion for geometrical spaces wrapped around the "holy" female body, and they are the inventions of a man accustomed to watching the world from a platonic viewpoint. A dress by Capucci is a metaphor that turns the woman who wears it into a metaphor herself. But it does not overwhelm her, on the contrary: it elevates her. It wants her to be alive, fully present with her heart and personality, as if the designer always bore in mind the saying by Majakovski, "Some dresses are so beautiful that they need a head on top." And thus, a new aspect is provided of the claim that Capucci is one of the greatest genuine artists ever in the field of Fashion; this new aspect sees Capucci as an exalter of woman, someone who allows her to rediscover her role as Woman and Domina, the Lady of a planet that envelops her in its best apparel and to which she proudly holds the keys to its coffers of bliss.

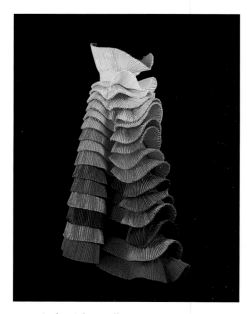

1992, Berlin, Schauspielhaus (Photograph by Amedeo Volpe).

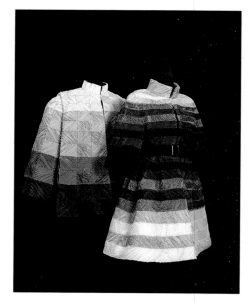

1992, Berlin, Schauspielhaus (Photograph by Amedeo Volpe).

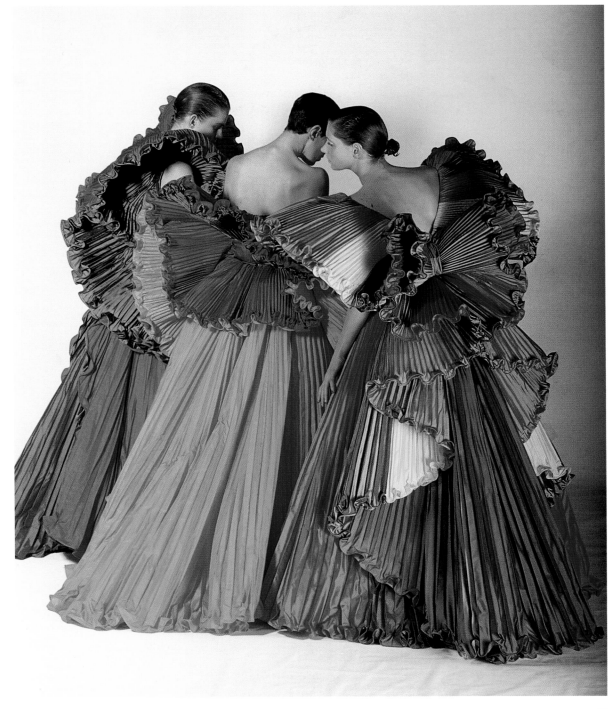

31

Maybe Capucci's dresses really do have a head. Worn syntax, lack of adjectives and poor grammar mean that the language of fashion is not capable of describing Capucci's work. The most heavily used adjectives, "sexy", "chic", "elegant", "sophisticated" and "*outré*" are insipid when used to describe his sculptural dresses. That is why one has to resort to hyperbolic, high flying adjectives like "wonderful", "fantastic" and "unrepeatable", but nor are these enough and the trap of rhetorical speech is always open for the verbose and careless writer. The expression "dream dress" is often used but it is a mistake. Capucci's creations are "the dreams of dresses." It is easy to imagine those plain "latest fashion" skirts, blouses and coats on their hangers in boutiques or department stores, dreaming at night of becoming "a Capucci": unique, irreplaceable, almost eternal, not subject to the brutal ephemerality of the fresh, so-called "new" fashion that changes every six months: the kind of fashion that touched the heart of Jean Cocteau because "it dies so young", and which made Chanel moan with boredom after the final rehearsal before a fashion show, "It is going to be fashionable for the next six months but it is already so old!" Dresses can dream, we know that. They have woolly ideas of interpreting those parts Capucci has assigned to a very few of them, the ones that will know the joy of always being up to date and never falling out of fashion. "The designer is faithful to his lifestyle," wrote Patrick Mauriés in *Roberto Capucci*, published by Franco Maria Ricci, "he remains outside the literary and public circles of the moment; however, this reserve of his does not prevent him from being influenced or sharing interests with them. It is clear that his fashion shares the same values of extravagance, an airy dreaming style and faint eccentricity with them, they are both marked by a sensitivity that finds its best breeding ground in the cultured but malicious environment of Rome."

We were talking about inspiration, that magic moment between what did not exist before and what is possible now, the moment of creation. "It was in Capri, in front of the purple and green colours of a large bougainvillaea flowering on the white wall of the Certosa." "It was in St. Peter's during a concert conducted by Karajan." "It was in South Africa—during my first photographic safari—I was watching a large colourful bird taking off from an ochre landscape." These are examples, in Capucci's words, of the origin of the forms of his dresses; dresses that are more like wrappings pulsating with emotion than examples of engineering perfection. These inspirations confirm that Capucci—an expert on art and the arts and a traveller of the world and the soul—does not imitate anyone or anything but develops feelings that metamorphose into shapes, and combinations of sensations that, when consecrated, are transformed into dresses. This is confirmation that, in Capucci's case, the boundary between art and fashion has faded away. Whereas fashion represents—perhaps rightly—the "*Zeitgeist*", i.e. the spirit of a particular age (which we recognise and even make fun of, as you do when you looking through old photo albums, "I looked so stupid in that tight shirt in 1971, I was so ridiculous with those shoulder pads in the Eighties, how strange we were, and how elegant we

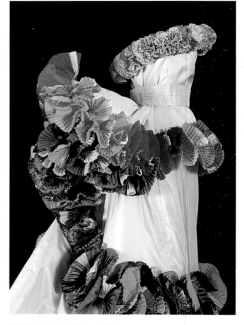

1992, Berlin, Schauspielhaus (Photograph by Amedeo Volpe).

Carlo Bertelli

An Explosion of Liberated Forms

Obstinately faithful to his early training as an artist (begun in the Academy of Fine Arts in Rome and continued even now with Capucci dedicating all his free time to visiting monuments, museums, cities and countries), Roberto Capucci considers his work to be a study of the figure. His preparatory experimentation using materials and drawings are his studies of the female figure; the finished works, on the other hand, are simply referred to as "figures." In his dresses, the luxury is so dazzling that it arouses wonder at a creative freedom unhindered by financial restraints or marketing strategies that focuses on exploring and celebrating the endless possibilities of a form of invention and creation that includes the understanding and imaginative use of materials, an explosion of liberated forms, and the creation of a relationship between an object and movement, i.e. between the dress and the body of the wearer.

As always, the study of the figure gives way to metaphysical questions because what is outlined and becomes increasingly precise is Capucci's conception of women. Although the engineering aspect of Capucci's dresses may remind us of Schlemmer's theatrical creations, in actual fact the similarity is not so great, though to him it is very important. Schlemmer's preoccupation with the movement of bodies as volumes and colours in space means he even hides the faces and limbs of

his characters. Capucci, on the other hand, always turns to possible or imagined characters.

To those, like the writer, who are new to the world of fashion, it seems that Capucci is inspired by different aspects of his personal conception of women, and this is particularly evident in his elaborately directed fashion shows in which the hard work of two years is finally displayed. The enchanting vision of a Capucci fashion show seems like a piece of theatre; they have an inner development that holds the whole together and does not allow extracts to be taken (although that, of course, is the ultimate aim and what justifies the show economically) while staging a riveting sequence of the different but absolute ways of being a woman.

Thus, the shows begin in an aggressive manner with a carefully chosen and refined soundtrack that develops into, on this occasion, a sort of initiation and rite. From the first notes, we see Walkyries protected by helmets that stiffen their faces as seen in arrogant photographs by Helmut Newton; they often wear boots that deliberately hide in rigid cases the most exposed part of a woman's body. Then the show moves on with a wide range of themes that might suggest Mogul or Persian miniatures, Spanish court dresses, the Fifteenth century in Italy, or studies taken directly from nature, for

1995, Venice
Cinabro, detail
(Photograph by Massimo Listri).

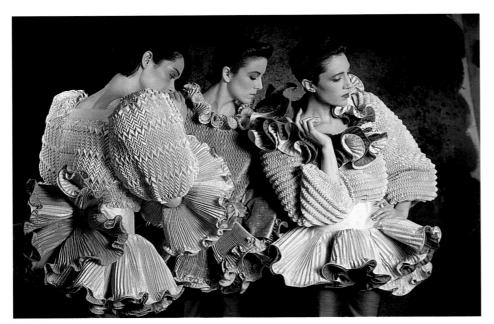

1985, New York, Extreme workmanship (Photograph by Fiorenzo Niccoli).

example, vivid impressions of sea anemones and other invertebrate sea creatures. For the designer of clothes that will be worn by unknown women, it is important to emphasise the face. Just like Roman portrait-statues were produced to "carry" a well-defined face, the extreme three-dimensionality of Capucci's dresses provides an elaborate base for a particular bust, i.e. the shoulders, neck, face and head that bloom in the same well-balanced forms that were used in the fifteenth century. This is the reasoning behind those designs in which tufts of grass or bunches of flowers sprout from the waist to create nymphs, allegories of spring or eighteenth-century shepherdesses.

This is the moment in which Capucci reveals his imaginative conception of the dress as a composition of parts. Not in the way a jacket is worn over a shirt but like pieces superimposed on a simple structure to complicate it. This notion has already been suggested by members of the avant-garde in the past and can also be seen in historical examples, for instance, Renaissance armour, the modifiable sleeves worn in the fifteenth and sixteenth centuries, and the series of kimonos with the extension around the base of the neck. Capucci, however, uses the notion of adding layers as the most suitable means of continuing a theme that was prevalent in his youth, when Irene Brin and Gasparo del Corso brought Surrealism to the Margherita Gallery and the Obelisk in Rome, when Dalí was working on productions by Visconti, when Eugène Berman was drawing in the Palazzo Doria in Via del Plebiscito, when Eléonor Fini scandalised the evenings of the bourgeoisie, when Alberto Savinio was writing his articles, and Gnoli had begun to attend the Old Vic. The Roman way of interpreting the painting style of Arcimboldo and the passionate surrender

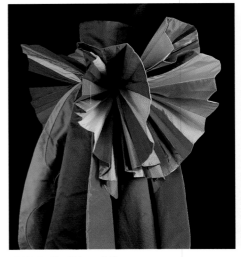

1992, Berlin, Schauspielhaus Detail (Photograph by Amedeo Volpe).

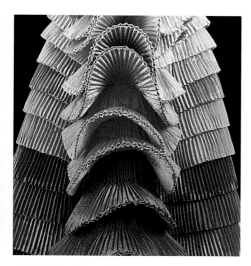

1992, Berlin, Schauspielhaus
Detail
(Photograph by Amedeo Volpe).

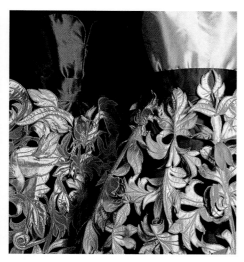

1992, Berlin, Schauspielhaus
Detail
(Photograph by Amedeo Volpe).

to the new, that were taking place with so many other things in the history of the world during Capucci's adolescence, provide him with the will-power he needs to transform a dress into a sculpture or a piece of architecture, like the transformation of a medieval column statue into a self-propelling tower by Tatlin.

The Surrealism that blew from the south during the period between Servandoni and Bernini in Scipio's city became the key to understanding his constantly surprising relationship with colour. Capucci uses colours with an unfathomable sensuality: cold colours are always carefully matched with warm ones, he never forgets whether the colour is inside or outside the dress, whether it is in contact with the body or forms part of the outer wrapping. The colour is revealed as the dress ripples, and is therefore able to show itself as sometimes modest, sometimes outrageous. The use of colour turns the observer into an insect, enticing him with details that resemble the elements of a flower: the *androecium*, the corolla, the calyx and the *gynaeceum*. The colours are far from being purely ornamental and are acutely missed in embroidered silver flowers on rigid satin in which the exuberant floral shape is chastised by depriving it of its colours. The matching of the colours, the relationship between the colours and the material, and the relationship between a colour and the size of its surface area are all aspects that deserve to be considered separately with many examples.

In contrast with the famous "boxed" dresses Capucci used to break all the conventions some years ago, now it seems that his ideas are heading more towards the relationship of the body with the dress to ensure the body does not get overwhelmed by the decoration. In studying this relationship, Capucci has compared various structures used in the design of European dresses from the past (such as the ribbing in women's dresses from the Baroque and Rococo periods) with the oriental tradition, so utterly different in the way clothes are cut, in the relationship between loosely hung and sewn materials, and in the hierarchy of garments. The close exploration of different artistic vocabularies has taught him linguistic associations that allow him to create bold transformations under our very eyes. With just a gesture, a dress changes its meaning, for example, the impenetrable cloak that hides the whole body is suddenly almost turned into a Renaissance panel used to highlight and frame the body, and then suddenly again into a shoulder cape hanging from the shoulders. Thus, an arm slightly raised under a cloak might produce the unexpected spiral profile of a violin or of a sari swelled by the wind. Naturally, the metamorphoses that occur during the fashion show are part of the spectacle but, more generally, they seem the result of a careful study of the relationship between the dress and movement; in addition, these metamorphoses indicate that the dresses are not fixed to either a time or social position. They play a fundamental role in the creative tension, which, however much it may appear the result of pure fantasy unrelated to practical aspects, ends by calling reality into question.

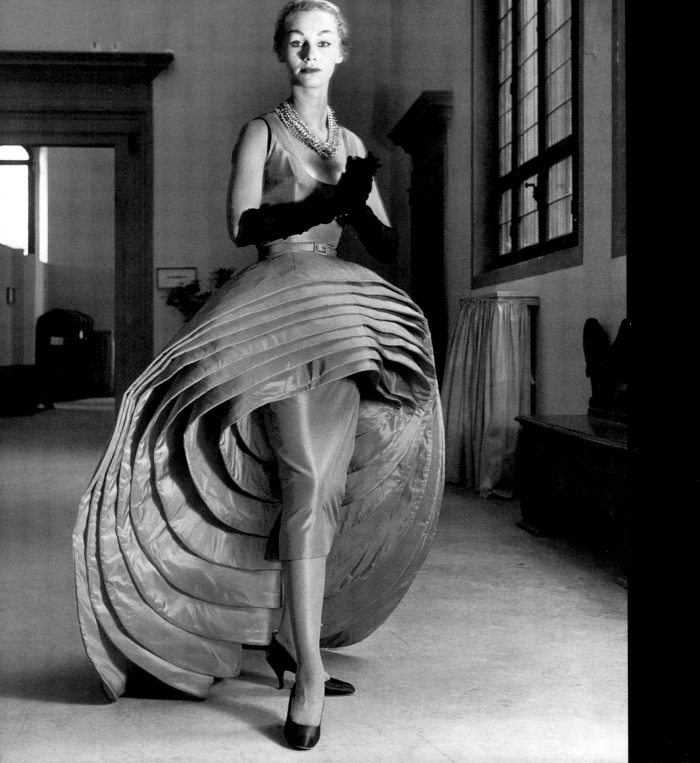

The Fifties

1951 was the year Roberto Capucci entered the fashion world, creating an immediate sensation and arousing admiration, just as still occurs, fifty years later, every time one of his creations is presented.

Born on 2 December 1930 in Rome, Capucci began his training at art school before moving on to the Academy of Fine Arts where he was taught by famous masters like Mazzacurati, Avenali and Libero de Libero. Capucci began working professionally in 1950 when he opened an atelier in Via Sistina in the capital.

Right from the start, it was Capucci's drawing skill that set his work apart, and it was his drawings that so struck Giovan Battista Giorgini in 1951. Without any hesitation, the Florentine nobleman who organised the Italian fashion shows invited Capucci to present his designs for the first time in July 1951 at the second of the Florence fashion events. The Roman designer's debut created a real stir, winning immediate success for the young Capucci in the nascent world of Italian fashion.

The Fifties were a time of continual growth and success for Roberto Capucci. He moved to a large studio in Via Gregoriana in 1955 and, a year later, just five years after his professional career had begun, Capucci received the sincere compliments of Christian Dior. The international press acclaimed him as the best Italian designer and he was awarded the Gold Medal in Venice at the first International Clothing show, "Fashion in Contemporary Costume." In 1958 he was awarded the prestigious Fashion Oscar in Boston for his design "*Linea a scatola.*" This was the first time the award had gone to an Italian.

Only a few more years had passed when Capucci decided to open an atelier in Paris as Dior himself had suggested during an interview with the journalist, Oriana Fallaci. On her return from France, Fallaci immediately let Capucci know Dior's comments by letter, "Dear Roberto, I went to interview Dior and he told me something I think you will be pleased to hear. He told me, 'In Italy you have a designer I admire very much. His name is Capucci. If you see him, please tell him I hope he will move to Paris'."
(Oriana Fallaci, in "Europeo", 17 December 1961).

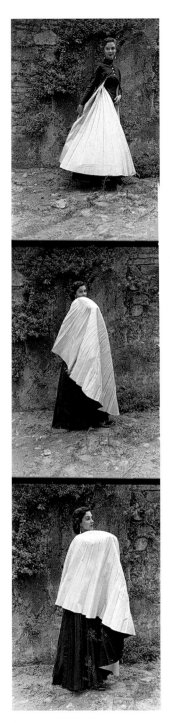
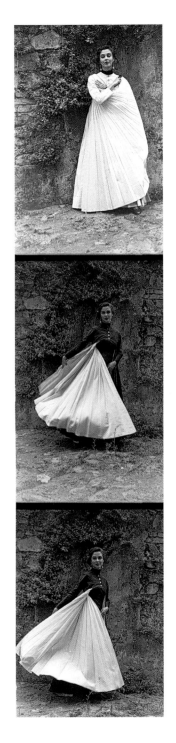
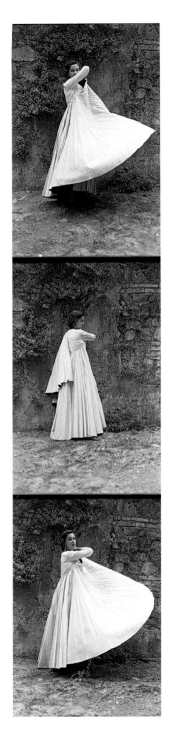

Page 38
1956, Florence
Dieci gonne dress
(Photograph by Renata Rieder,
Capucci Historical Archive).

1951, Florence
The First Collection
(Capucci Historical Archive).

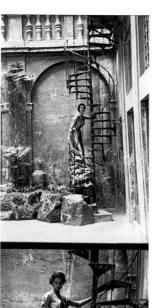
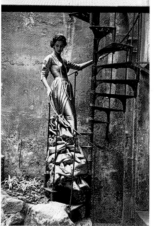
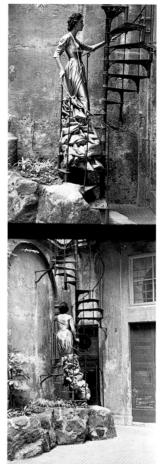
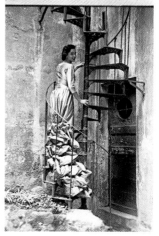

1956, Autograph drawing by Roberto Capucci (Capucci Historical Archive).

1956, Florence
(Photograph by Bertazzini,
Capucci Historical Archive).

1957, Creativity and the media
(Capucci Historical Archive).

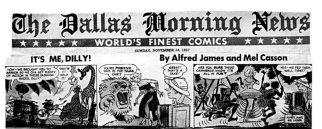

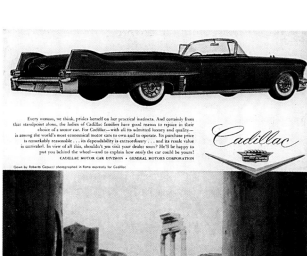

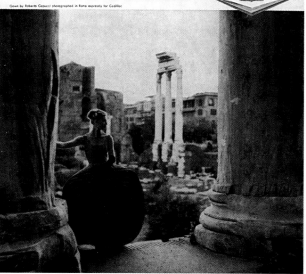

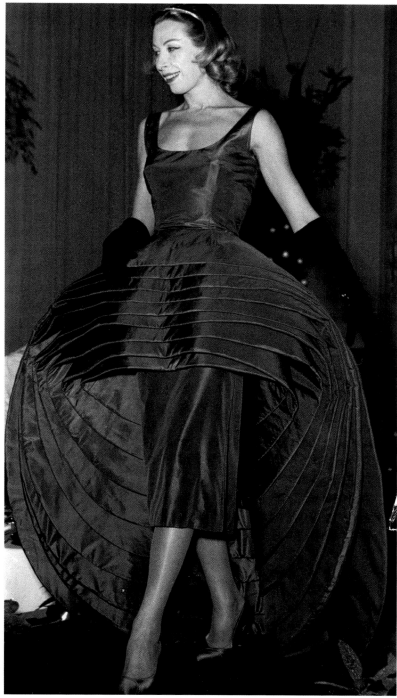

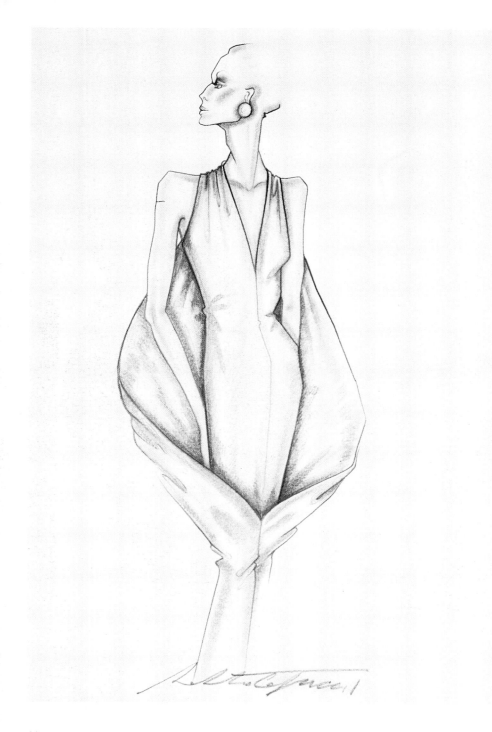

1956, Autograph drawing
by Roberto Capucci
(Capucci Historical Archive).

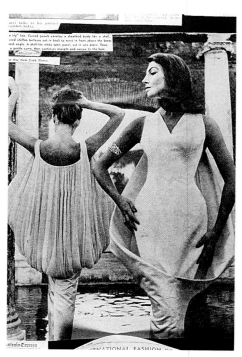

1956, Creativity and inspiration
(from "The New York Times",
photograph by Sharland;
Capucci Historical Archive).

1956-1957, Autumn-Winter
Linea a bocciolo
(Capucci Historical Archive)

Photograph by Regina Relang.

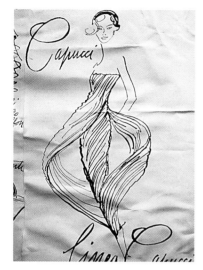

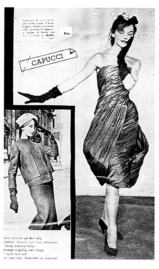

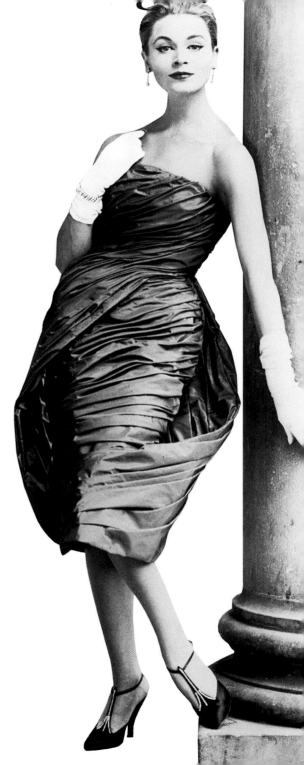

1958, Linea a scatola
*Capucci's first notebook
sketches
(Capucci Historical
Archive).*

1958, Linea a scatola
From sketch to media
(Capucci Historical Archive).

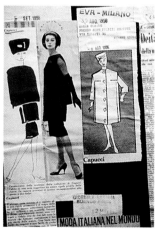

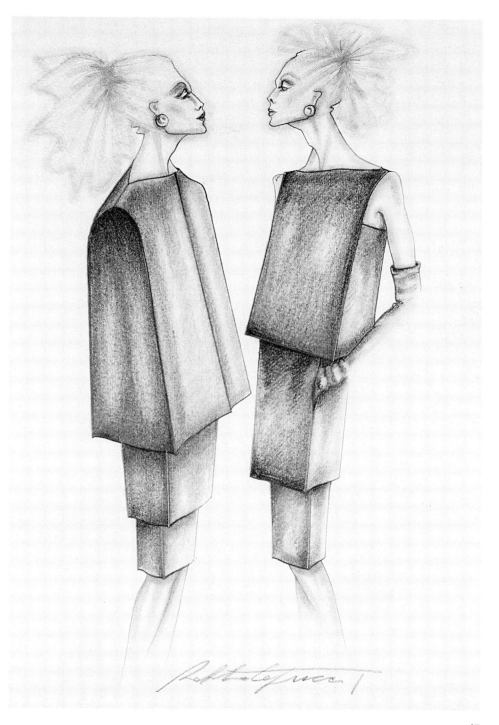

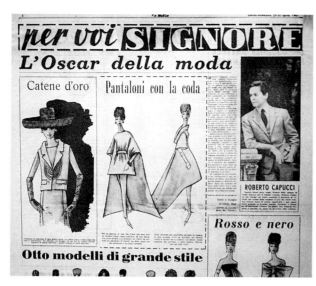

1958, Boston, the Fashion Oscar
for Linea a scatola
(Capucci Historical Archive).

1958, Boston
Pierre Cardin, Carita and Capucci
(Capucci Historical Archive).

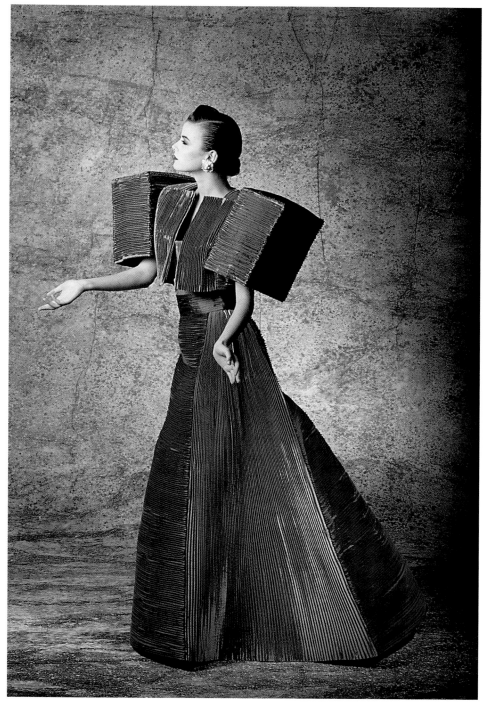

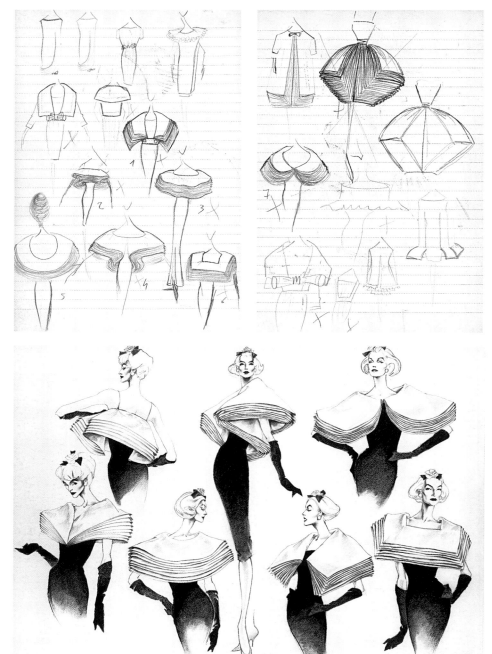

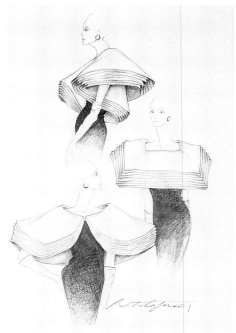

1959, Contrasts and geometrical forms (sketches and drawings by Capucci and Stefano Canulli, Capucci Historical Archive).

1959, Press articles and the reality
(Capucci Historical Archive)

Photograph by Johnny Moncada.

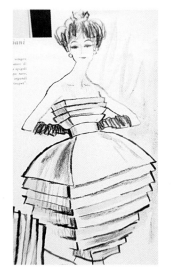

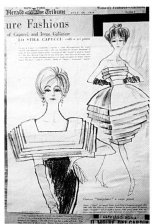

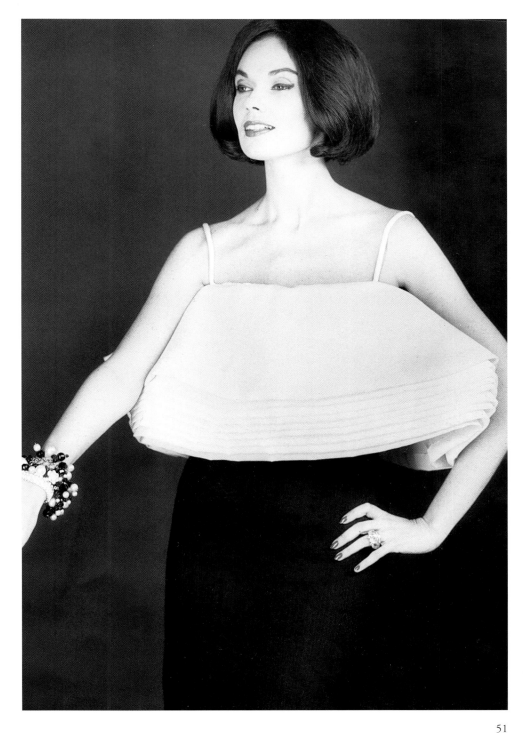

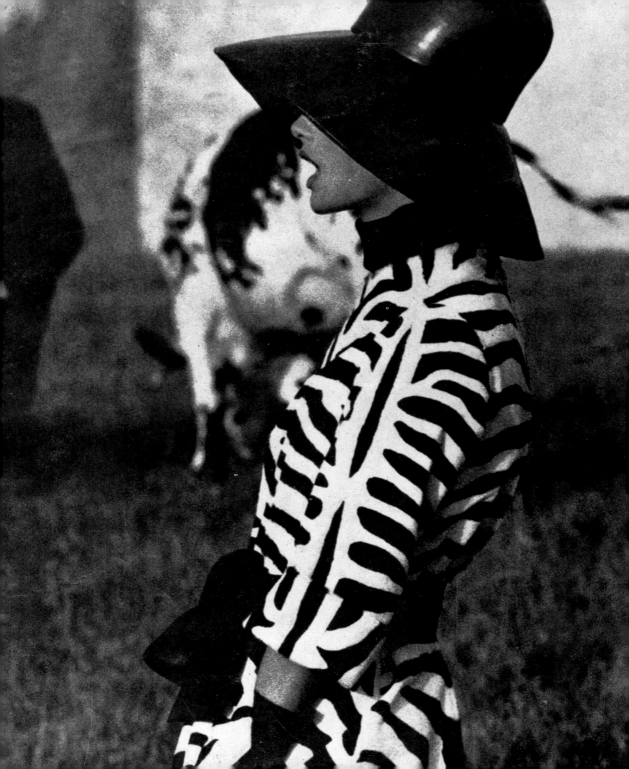

The Sixties

The Sixties were closely linked to the opening of Capucci's Paris atelier at a very prestigious address—4, Rue Cambon—just a couple of steps from Coco Chanel's atelier. Equally esteemed were the staff Capucci chose: there was Madame Germaine (*la première*) who had been Dior's fashion designer, Madame Marguerite who had worked on the historical New Look, skilful cutters were wooed away from the Givenchy and Chanel *maisons*, and the press office was staffed by Madame Josette, the former secretary to the writer Colette.

Capucci's arrival in the capital of *haute couture* was marked by admiration and enthusiasm but in Italy all the newspapers accused him of "betrayal" and his Italian colleagues never forgave him his transferral to the rival camp.

After several triumphant seasons in Paris, the show presenting his 1965 collection became a historical event when, being luminescent, all his designs were presented in the dark. Three years later, the Roman designer decided it was time to return to Italy and centred all his creative work in Via Gregoriana.

During these years Capucci showed synthetic fibres the same curiosity and experimental doggedness that were to mark his constructions using straw, stones and brass during the following decade.

Capucci's designs of the mid-Sixties gave a tangible sense to the expression "new textiles" within an aesthetic in which the fabrics, whatever their origin, were the substance of a vision. His collections were not only shown in Paris but also in the Venice shows organised by the Italian Fashion Centre that had been created in 1948 by the President of Snia Viscosa, Franco Marinotti, with the aim of heightening appreciation of artificial textiles through their use in fashion.

The two famous dresses created by Capucci in 1966—one a veil of plastic trimmed with white grosgrain and the other made from white cotton lined with transparent plastic with white embroidered inlays—remain a unique and comprehensive lesson in style today.

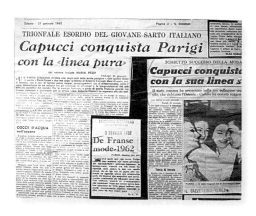

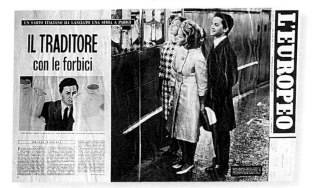

Page 52
1962-1963, Autumn-Winter
Optical camouflage
(Photograph by Norman Parkinson
taken from the magazine "Queen").

Page 54
1962, Paris
Capucci's triumph
(Capucci Historical Archive).

1960-1961, Autumn-Winter
Optical contrasts with meshed
bands
(Capucci Historical Archive).

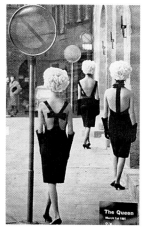

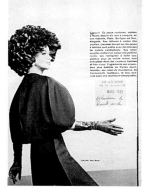

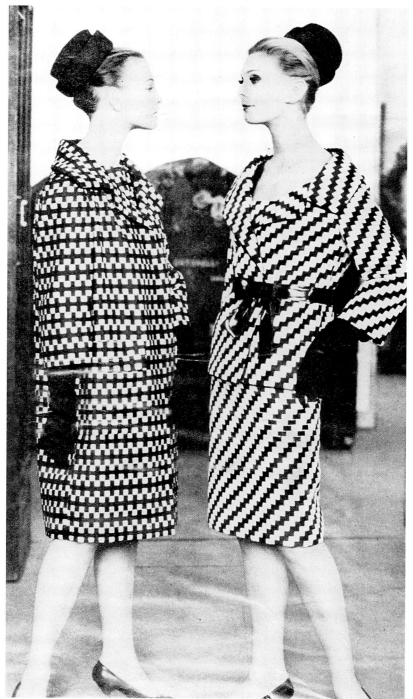

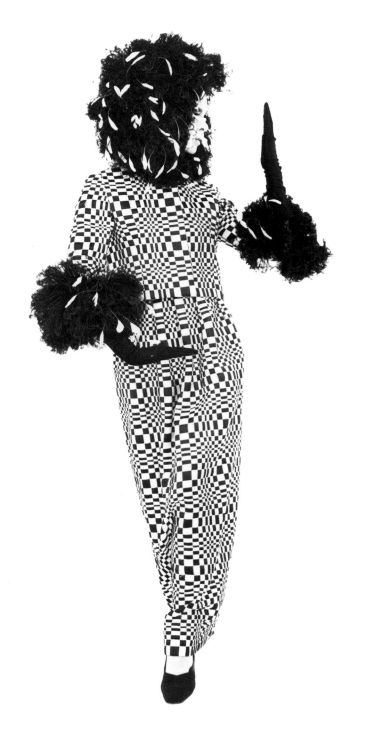

1965-1966, Paris, Autumn-Winter
Optical fantasies with meshed
bands
(Capucci Historical Archive).

1962, Rome
(Photograph by Regina Relang,
Capucci Historical Archive).

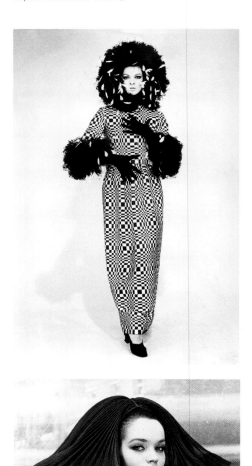

1960, USA
The tribute paid by Neiman Marcus
(Photography by Gilbert, Capucci
Historical Archive).

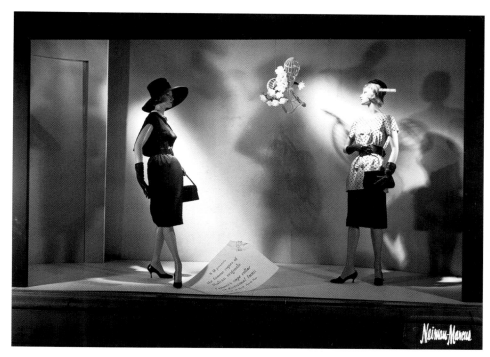

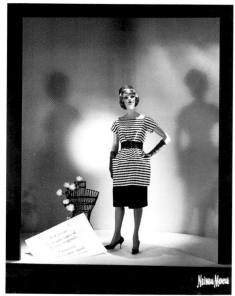

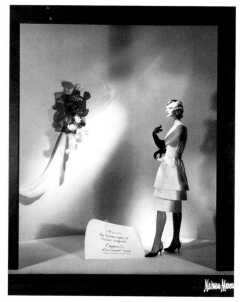

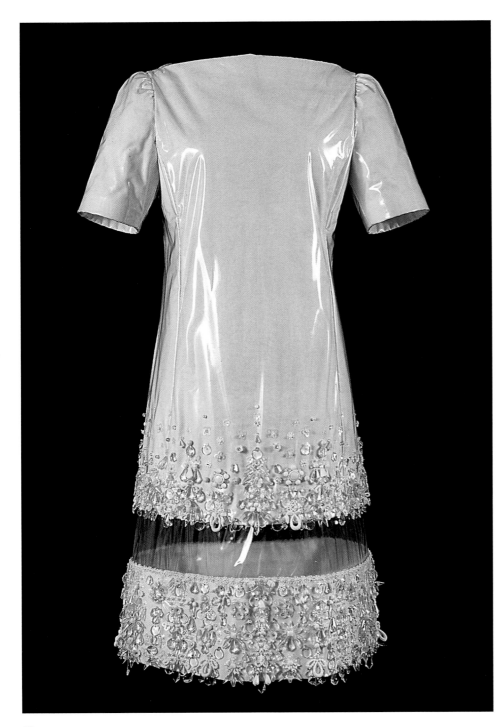

*1966, Paris, Spring-Summer
Material experiments
(Photograph by Amedeo Volpe).*

*1967, Paris, Spring-Summer
Autograph drawing by Roberto
Capucci
(Capucci Historical Archive).*

*1966, Paris, Spring-Summer
Geometry and experimentation
(Photograph by Amedeo Volpe).*

*1966, Paris, Spring-Summer
Autograph drawing by Roberto
Capucci
(Capucci Historical Archive).*

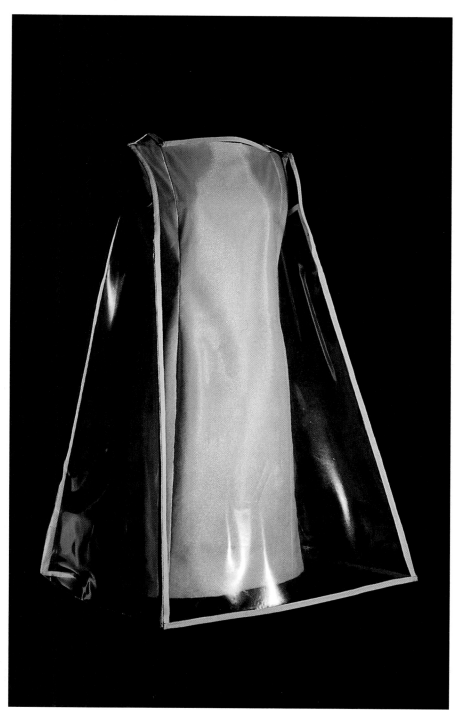

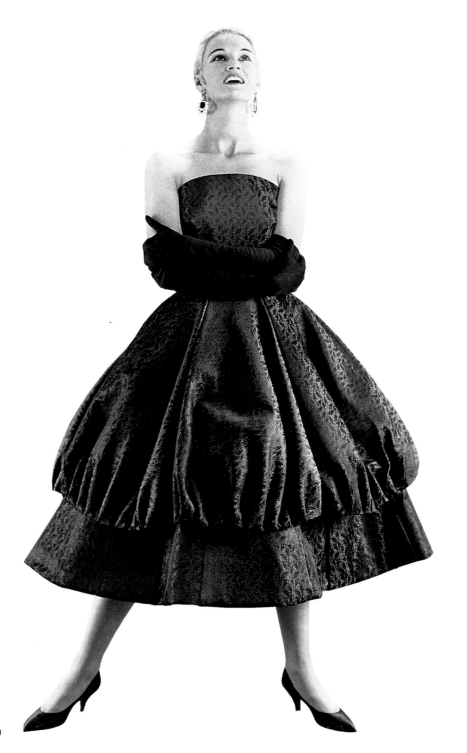

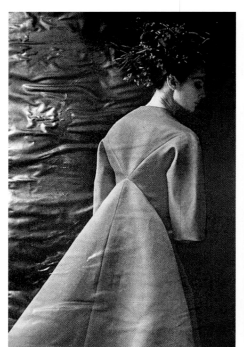

1966, Venice
Italian Fashion Centre
Experimentation with artificial
fabrics.

1962, Paris
Geometrical forms
(Photograph by "Life Magazine",
Capucci Historical Archive).

*1962, Paris
(Capucci Historical Archive).*

*1969-1970, Rome, Autumn-Winter
Autograph drawing by Roberto
Capucci
(Capucci Historical Archive).*

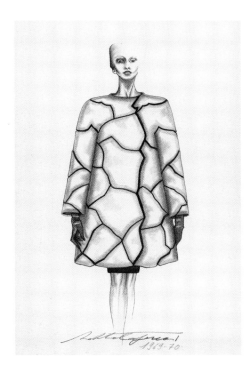

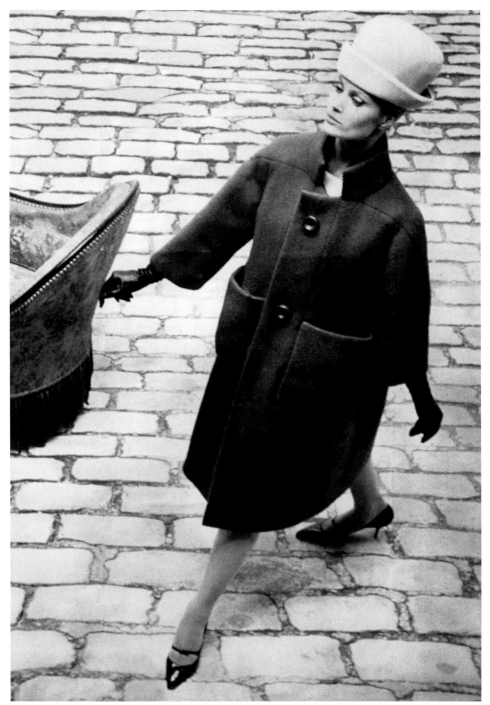

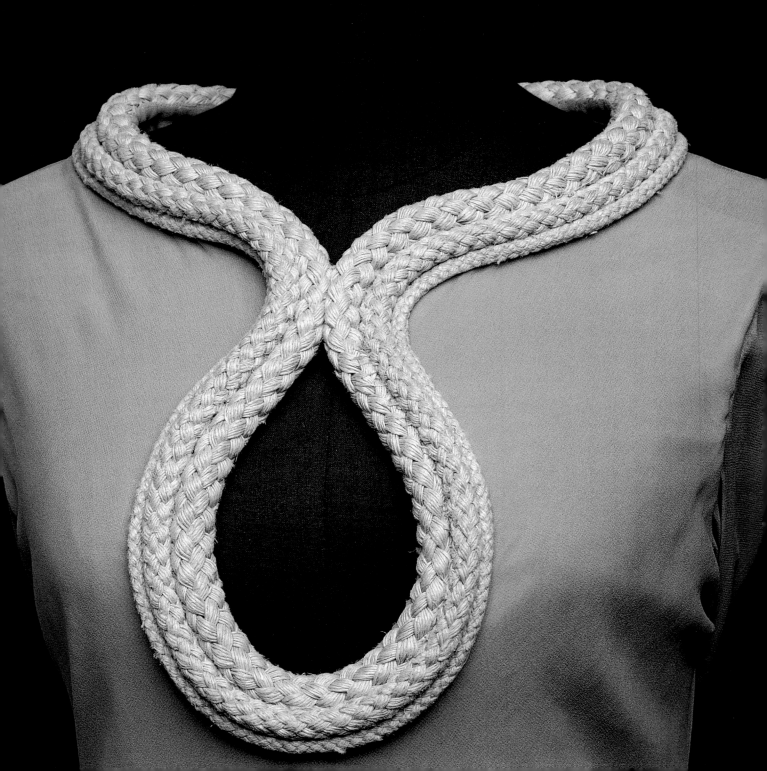

The Seventies

The Seventies were a period of further and continual experimentation by Capucci with particular emphasis on the use of various materials that were avant-garde for the time, for example, raffia, straw, stones and pebbles used with distinct, high quality fabrics.

1970 was the year of Capucci's only work in the world of the cinema when the director Pier Paolo Pasolini asked him to design the costumes for the film *Teorema*. Capucci was charmed by the idea and accepted immediately before even he found out that Silvana Mangano played the main character. Right from his first meeting with the actress, with whom he was to make friends, Capucci considered her "a vision of absolute harmony."

"In 1970, Pasolini asked me to design the clothes for the film *Teorema*," Capucci recalls. "He came to my atelier and quickly explained what the film was about in his calm and amiable manner. He asked me, quite correctly, that the characters should not be dressed too fashionably so that twenty to thirty years later the film would not appear too dated. And he also asked me to dress the main character in pale hues and only to put some colour into her clothes at the end when she discovered love (and that's what I did, beige and sandy colours at the start, then at the end coral red). When I learned that the actress was Silvana Mangano, I accepted enthusiastically. She was the most beautiful woman I had ever met and to dress her was a dream. She was very difficult, silent and shy, and she made me uneasy. Pasolini said to me, 'Break the ice and you will discover an extraordinary woman underneath'. And it was true. We became great friends. She was so beautiful, fascinating and evanescent. She had something more than other women, something I wouldn't know how to explain. I put her in a black sheath, straight and very simply made, and it seemed as though she was wearing something from *haute couture*. And when she wore an evening dress, she wore it with great instinctive naturalness as though she were wearing nothing at all. She had a magic like few others."
("L'Unità", 20 April 1994).

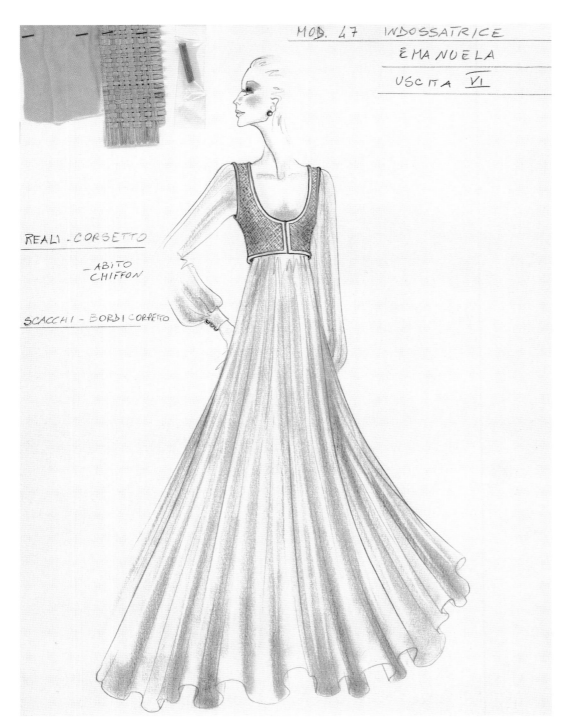

MOD. 47 INDOSSATRICE
EMANUELA
USCITA VI

REALI - CORSETTO

— ABITO
CHIFFON

SCACCHI — BORDI CORPETTO

Page 62
1971, Ropes, detail
(Photograph by Amedeo Volpe).

1972, Spring-Summer
Original Capucci drawing
(Capucci Historical Archive).

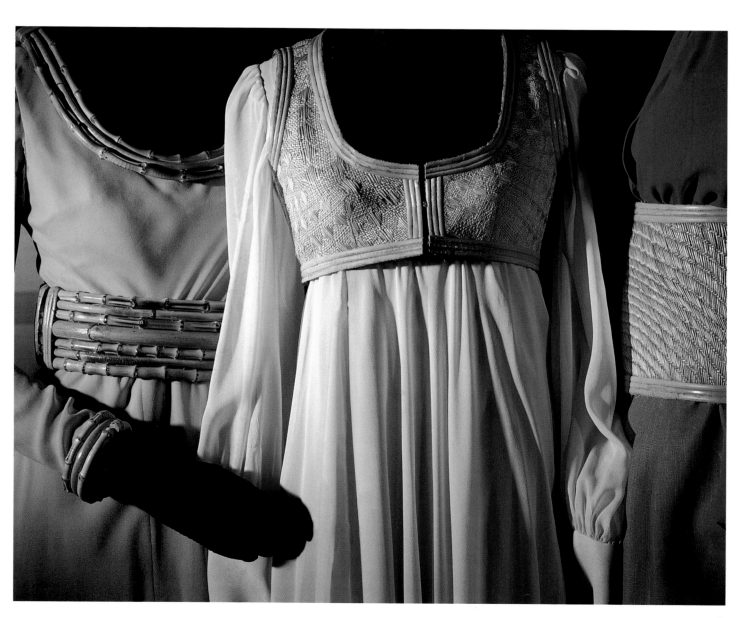

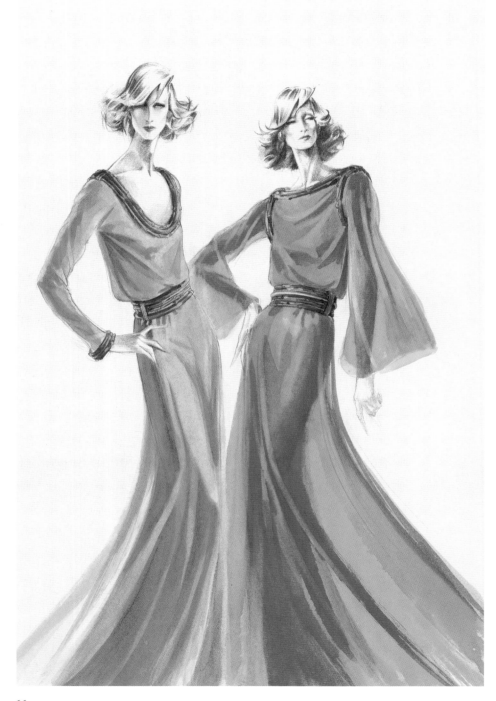

1972, Drawing by Stefano Canulli (Capucci Historical Archive).

*1972, Drawing by Stefano Canulli
and Roberto Capucci
(Capucci Historical Archive).*

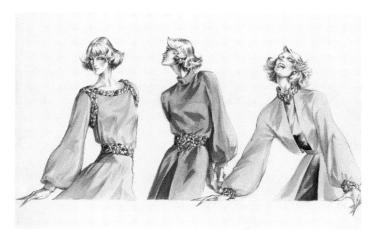

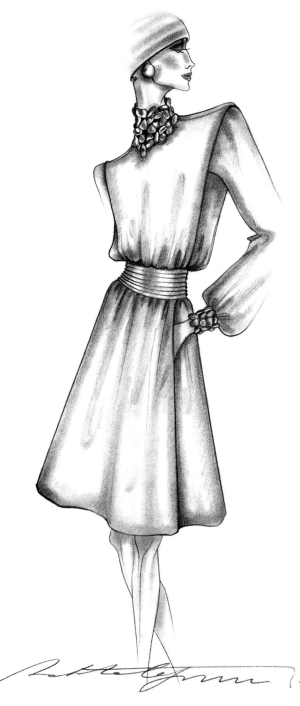

1972.

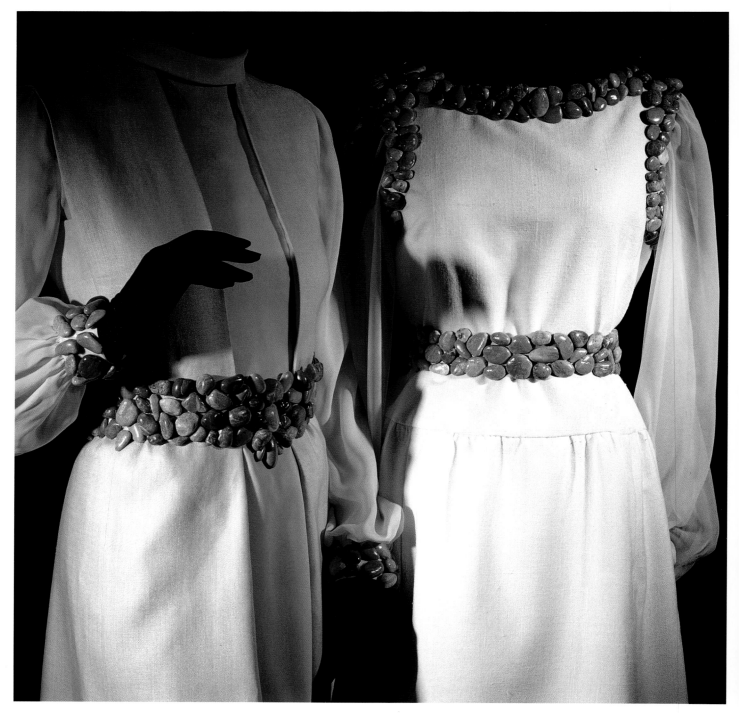

1972, Stones
Experimentation and contrasts
(Photograph by Mino La Franca).

1971, Spring-Summer
Ropes
(Capucci Historical Archive).

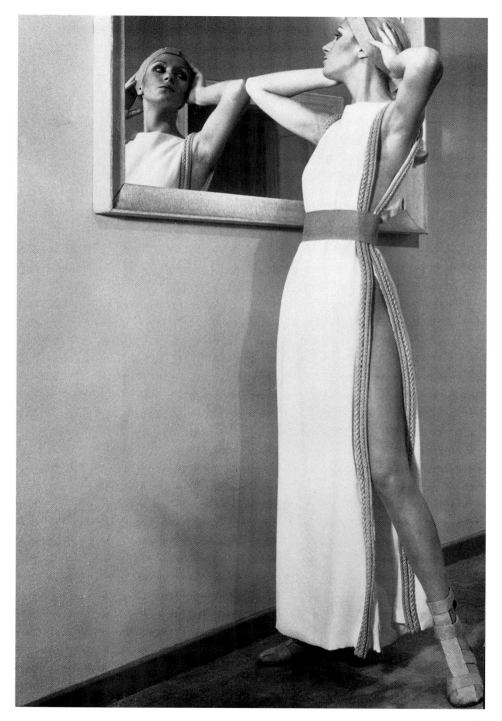

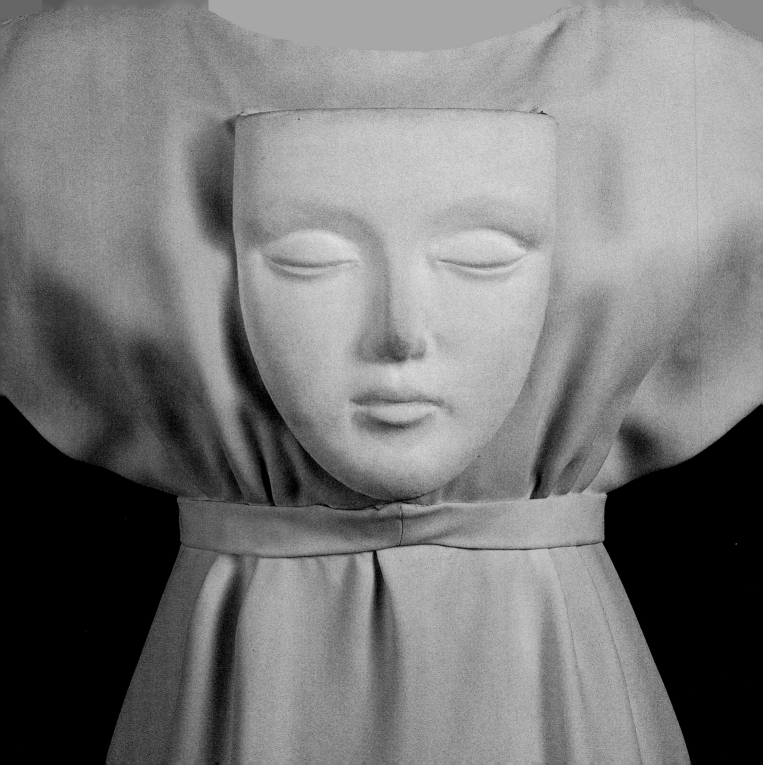

The Eighties

The desire to experiment that had always been strong in Capucci became more marked with time as did his need for independence and complete freedom in which to work.

The Eighties therefore signalled a move away from the institutional structures that underlie the fashion world. Capucci decided to design just one collection a year and to present it in a different city on each occasion, "The one that is willing to welcome me," he said. Not only that, but each show was to be like a one-man exhibition by an artist. The locations of the shows for that period were Palazzo Visconti in Milan (1982), the Sumitomo Corporation in Tokyo (1983), the Italian Embassy in Paris (1984), the National Guard Armory in New York (1985), the Palazzo Venezia Museum in Rome (1987), The National Gallery of Modern Art in Rome (1989) and the Madame Fashion Show in Munich (1989).

Two other important events took place in the Eighties.

1984: the creation of the dress-costume *La Donna Gioiello* for the exhibition "Dogi della Moda" which is now part of the permanent collection at the Fortuny Museum in Venice.

1986: *Omaggio alla Callas*. For the first time, Capucci got involved with the theatre on the invitation of the organising body of the Arena in Verona on the occasion of the famous live television broadcast, "This is the Arena. This is where Maria Callas was born" dedicated to the famous Greek soprano. Capucci's contribution was the design and production of the twelve costumes for the priestesses in Bellini's opera *Norma*. They costumes appeared at the most moving and thrilling moment of the production: as Callas's voice sings the aria *Casta Diva*, the twelve snow-white priestesses processed towards the centre of the ancient amphitheatre. Some of these costumes are now displayed in museums in Italy and abroad: Milan, Florence, Venice, Munich and London.

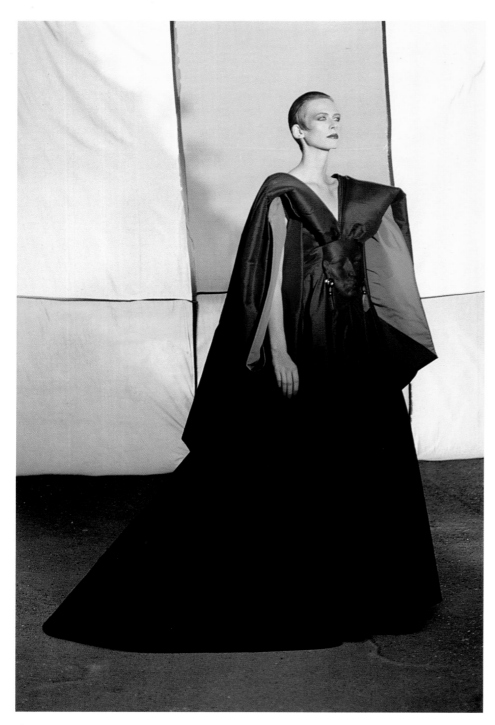

Page 70
1980, Paris
The enigma of creativity
(Photograph by Amedeo Volpe).

1984, Paris
(Photograph by Fiorenzo Niccoli).

1984, Paris
(Catwalk photograph, Capucci
Historical Archive).

1984, Drawing by Stefano Canulli
(Capucci Historical Archive).

1984, Paris
Fibreglass mask
(Photograph by Massimo Listri).

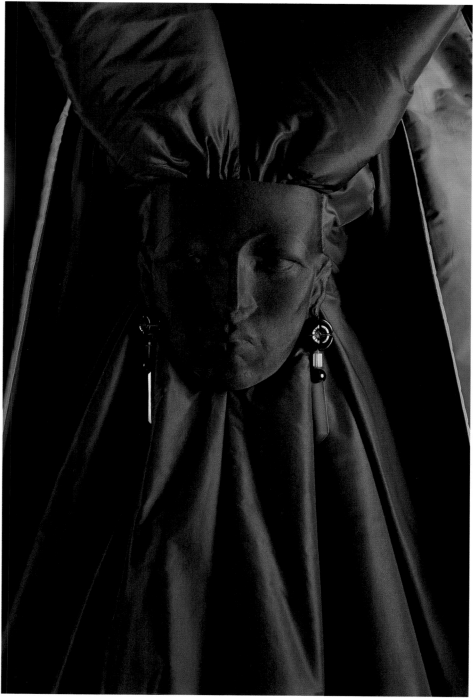

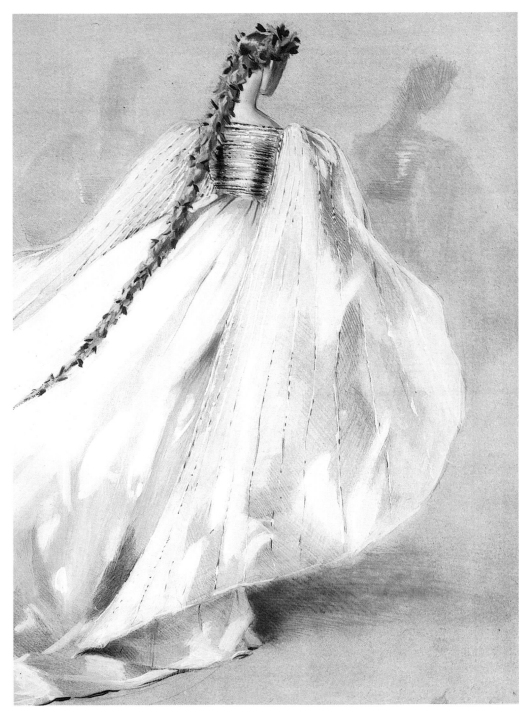

1986, Verona, Omaggio a Maria Callas, *vestal virgin for* Norma
Drawing by Stefano Canulli
(Capucci Historical Archive).

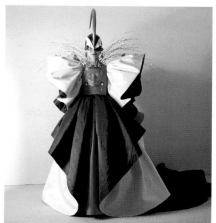
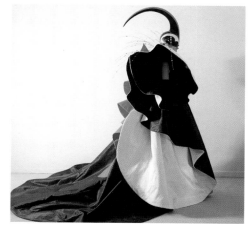

1984, La Donna Gioiello,
Autograph drawing
by Roberto Capucci
(Capucci Historical Archive, right,
photographs by Uberto Gasche).

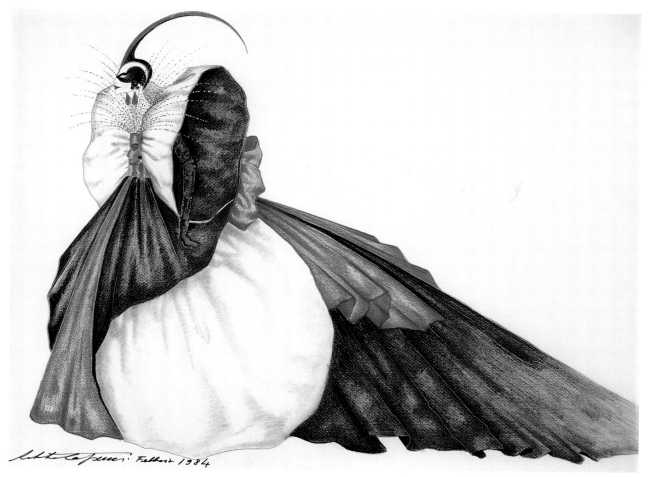

1980-1981, Rome
Autograph drawing
by Roberto Capucci
(Photographs by Amedeo Volpe
and Fiorenzo Niccoli).

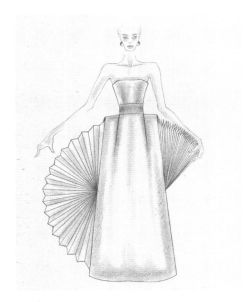

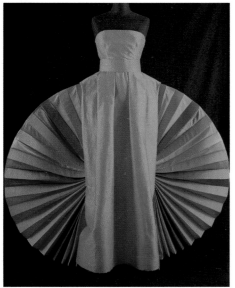

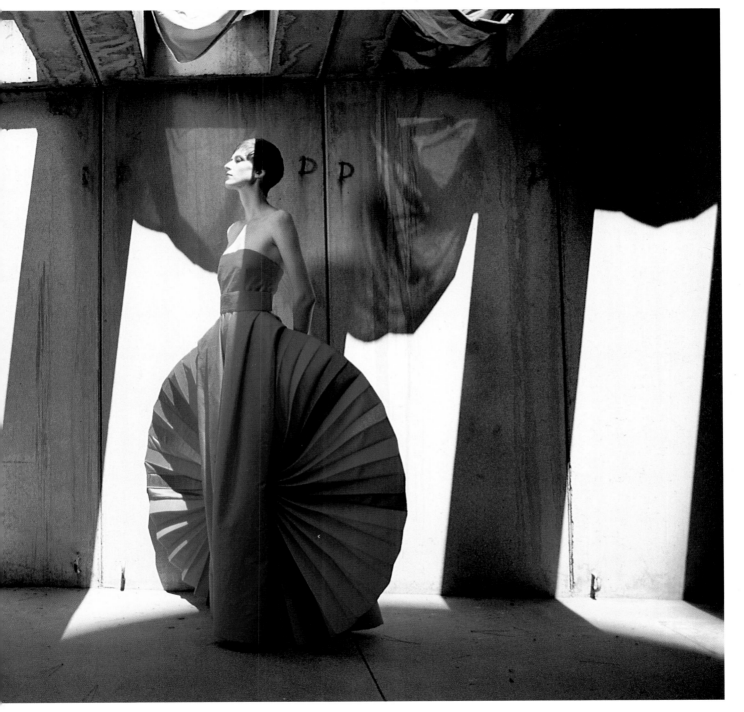

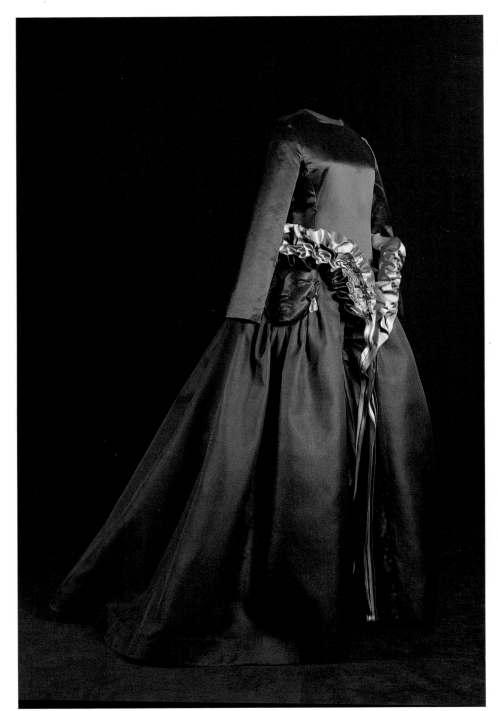

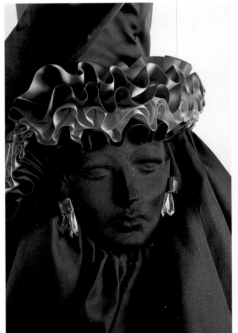

*1984, Paris
(Photographs by Amedeo Volpe
and Massimo Listri).*

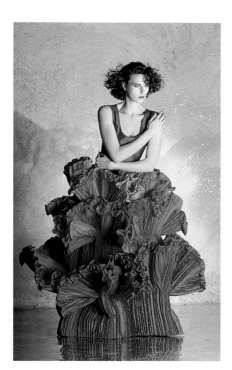

1985, New York
Sauvage in various tones of red
(Photograph by Fiorenzo Niccoli
and autograph drawing by Capucci,
Capucci Historical Archive).

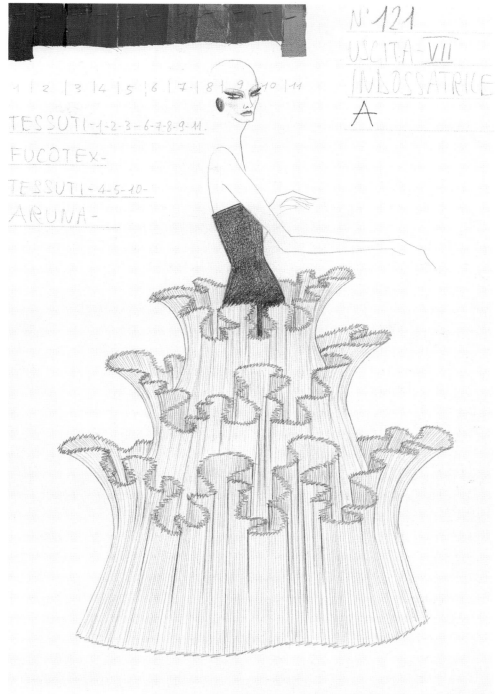

79

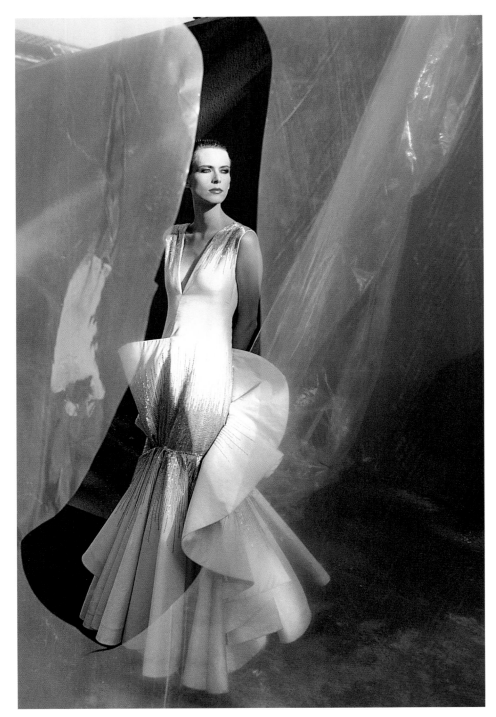

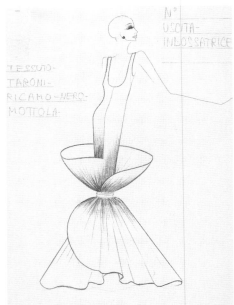

1984, Paris
(Photograph by Fiorenzo Niccoli).

1984, Paris
Original drawing by Capucci
(Capucci Historical Archive).

*1984, Paris
Catwalk photograph
(Capucci Historical Archive).*

*1984, Paris
Drawing by Stefano Canulli
(Capucci Historical Archive).*

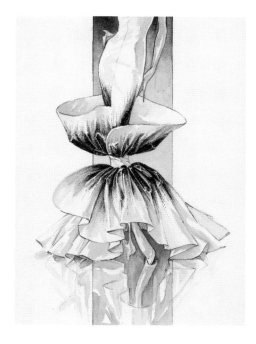

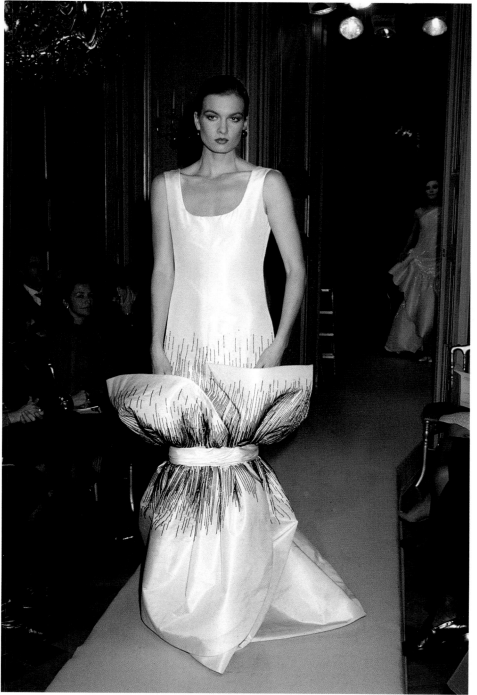

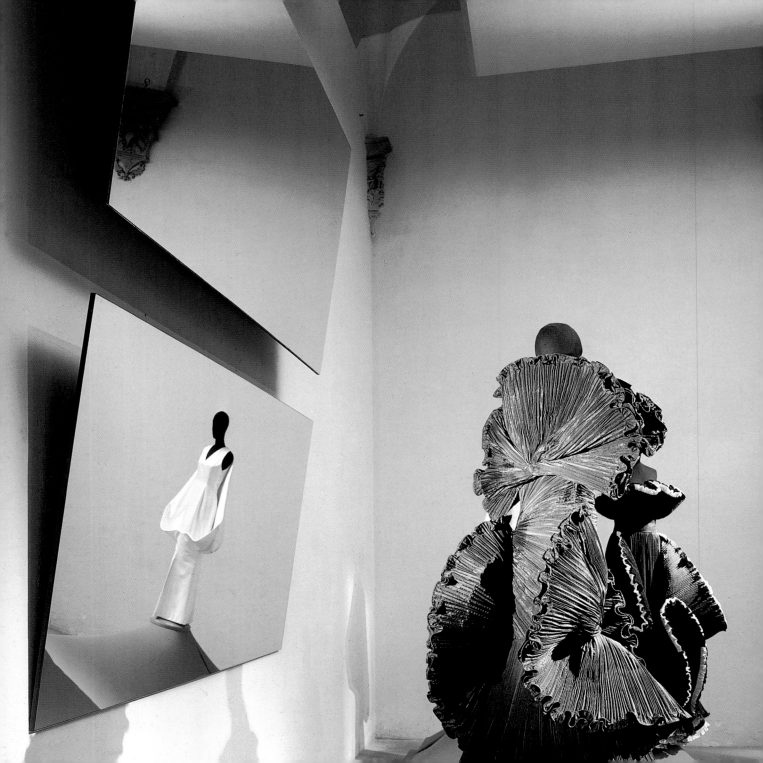

The Nineties

During the Nineties, Capucci was increasingly involved in important artistic events and international exhibitions.

Collections of his sculptural clothes, each one unique, appeared only in 1992 and 1994 at the Schauspielhaus in Berlin, Schonbrunn Castle in Vienna and Eggenberg Castle in Graz, but his name was continually linked with those of great artists in other fields, for example, Picasso, Henry Moore, Giacometti and Balthus on the occasion of his 1993 Paris exhibition, "Regards sur la Femme".

The following year, he was made a member of the Academy of Fine Arts in Milan together with the sculptor Francesco Messina, the film director Bernardo Bertolucci and the painter Toti Scialoja. This prestigious recognition is awarded to people who work in the arts, the sciences and literature.

In 1995, on the invitation of Mrs. Wu Yi, the Minister of Foreign Trade of the People's Republic of China, he gave seminars on art in fashion at the universities of Beijing, Xi'an and Shanghai and presented his museum creations in the first edition of the event "La via di Marco Polo." That same year he was one of the twenty artists invited by Jean Clair to participate in the Italian section of the XLVI International Art Exhibition that marked the one hundredth anniversary of the Venice Biennale. For the occasion he designed twelve tapered sculptural-architectural dresses inspired by nature.

In 1996, the Teatro Farnese in Parma hosted a show dedicated to Capucci's work, with his creations exhibited as though they were the characters in a stage production and the audience: the tenth phantasmagorical production in the secular history of the theatre. Two years later, on the invitation of the Italian Minister of Trade, Capucci produced one of his most sensational sculptural dresses for the World Expo in Lisbon titled *The ocean, the future of the seas*; the dress was produced in twenty seven different shades of blue.

His latest design, the result of advanced experimentation, was produced especially for the exhibition "Roberto Capucci. Timeless creativity" displayed in the Arsenale in Venice. The dress-cum-sculpture is made using Meryl Nexten produced by Nystar, the first hollow fibre in the world. Using this highly technological and modern material, Capucci has produced another eulogy to beauty; based on an architectural-geometrical structure, the colour seems to explode from the essence of the textile sculpture towards the infinite

Page 82
1990, "Roberto Capucci. Volume,
Colore, Metodo", Palazzo Strozzi,
Florence
(Photograph by Arrigo Coppitz,
Capucci Historical Archive).

1990, Palazzo Strozzi
Florence
(Photograph by Arrigo Coppitz,
Capucci Historical Archive).

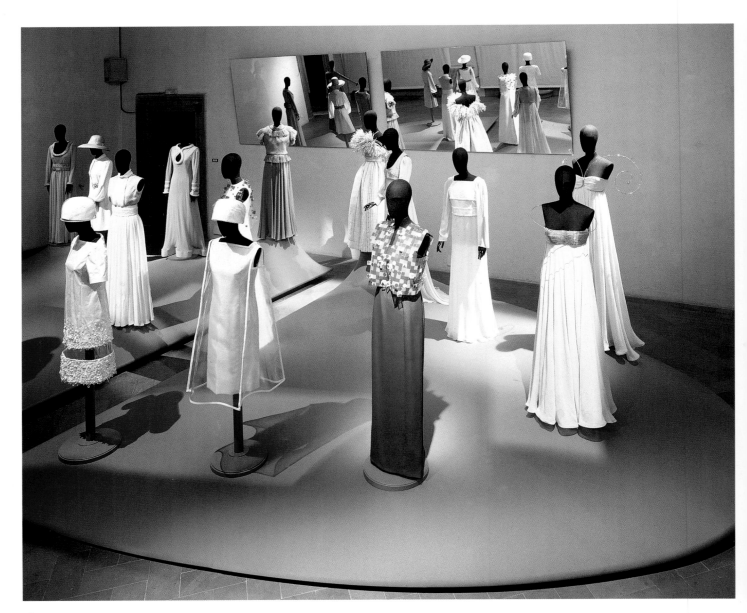

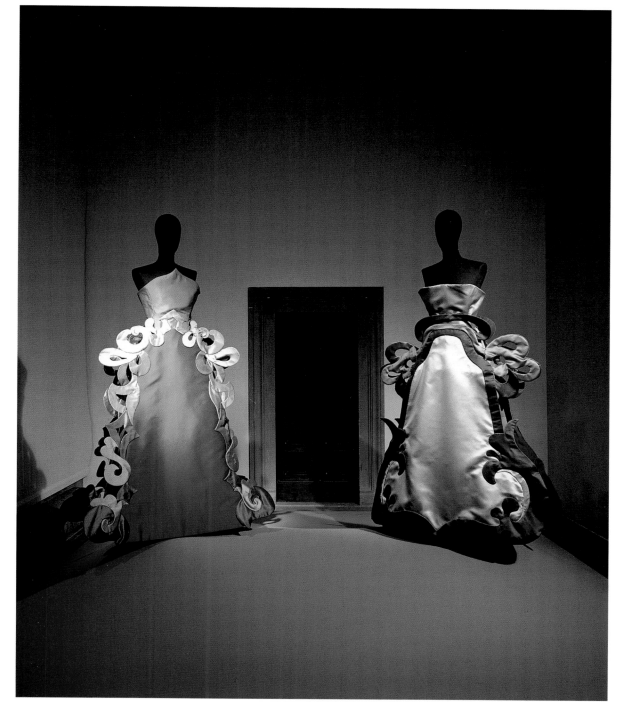

1990, Palazzo Strozzi Florence (Photograph by Arrigo Coppitz, Capucci Historical Archive).

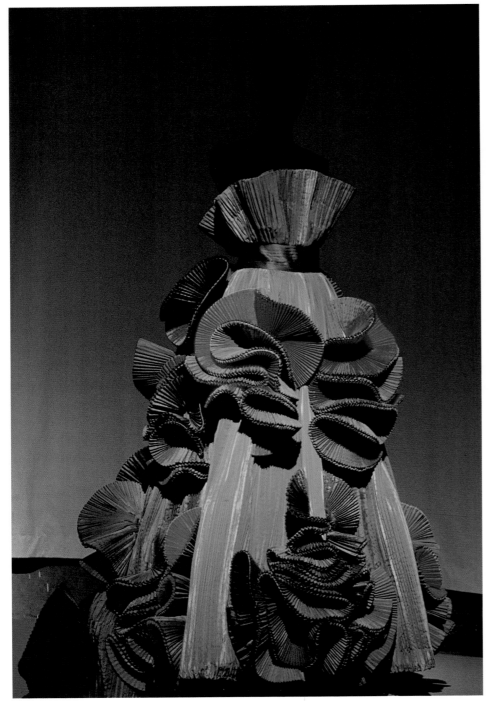

1990, Palazzo Strozzi
Florence
(Photograph by Giacomo Artale).

1991, "Roberto Capucci, Roben wie
Rustungen", Kunsthistorisches
Museum, Vienna
(Photograph by Johann Kräftner).

1991, "Roberto Capucci, Roben wie Rustungen", Kunsthistorisches Museum, Vienna (Photograph by Johann Kräftner).

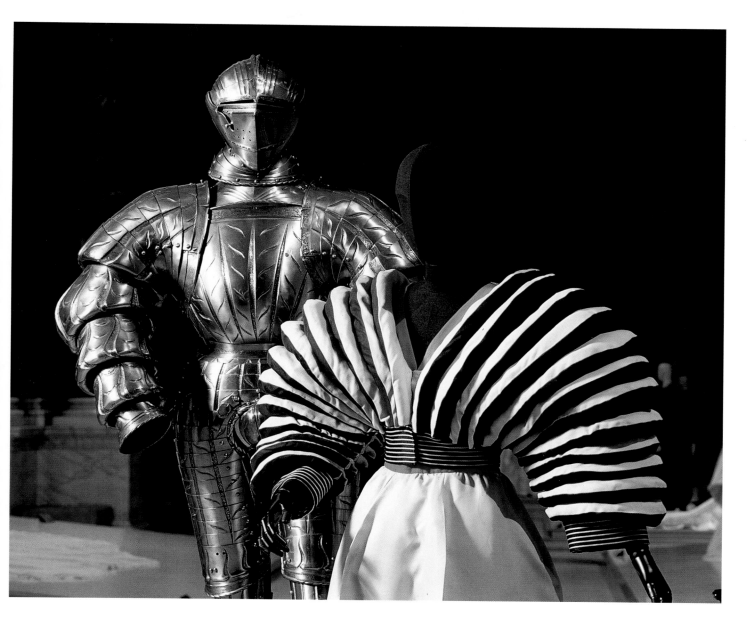

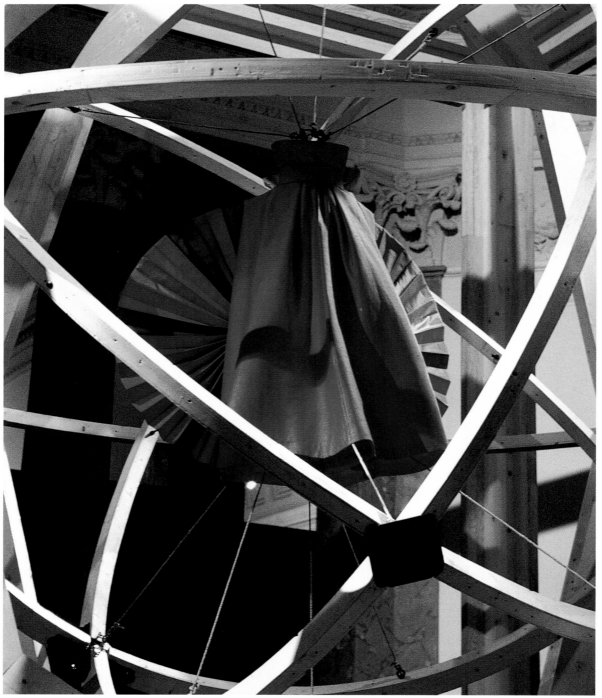

1994, "Roberto Capucci. I percorsi della creatività", Palazzo delle Esposizioni, Rome (image taken from video by Rubino Rubini, Capucci Historical Archive).

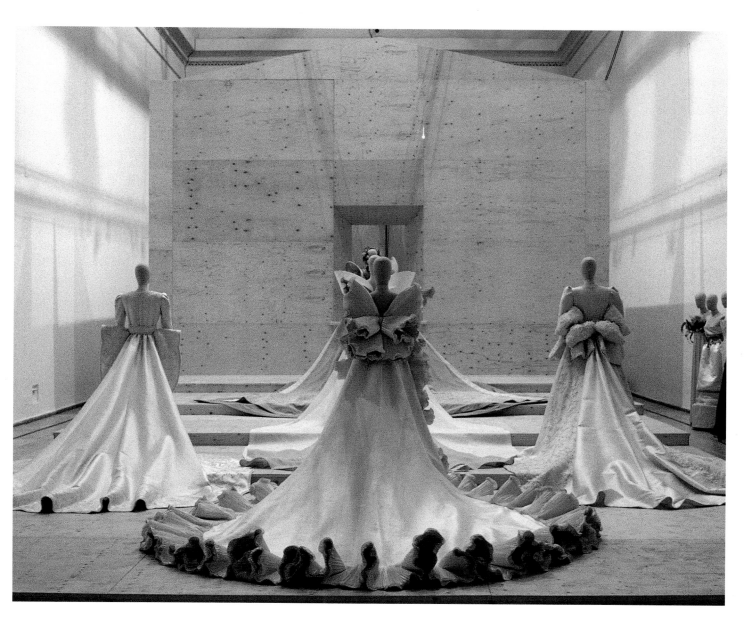

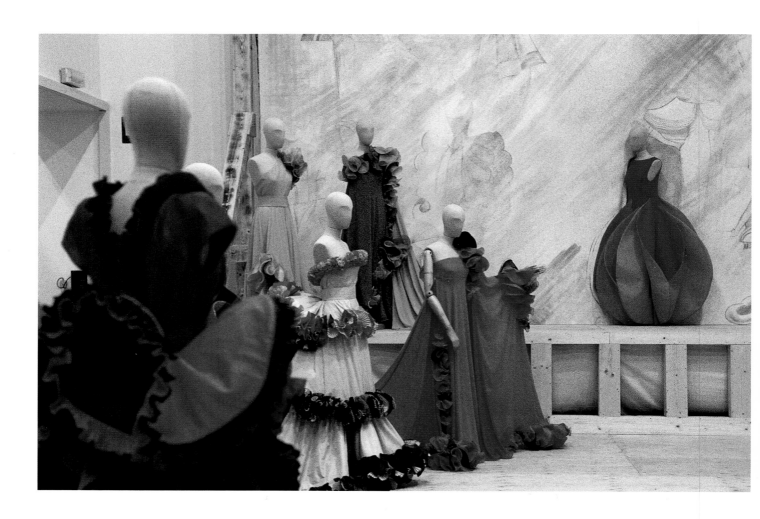

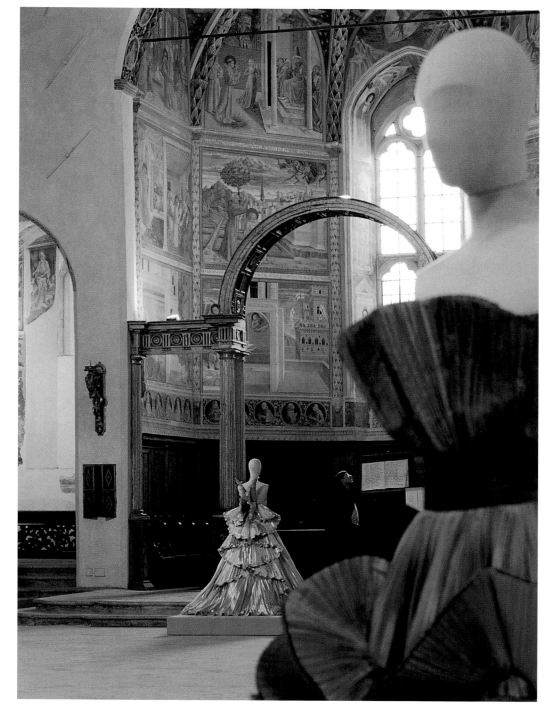

1994, "Opere di Roberto Capucci tra quelle di Gozzoli e Perugino", Montefalco, Perugia (image taken from video by Rubino Rubini, Capucci Historical Archive).

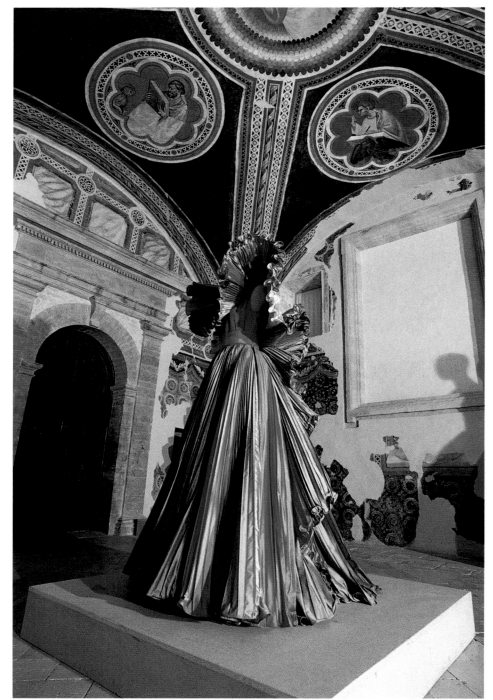

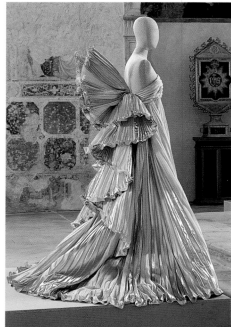

1994, Montefalco, Perugia
(Image taken from video by Rubino
Rubini, Capucci Historical Archive).

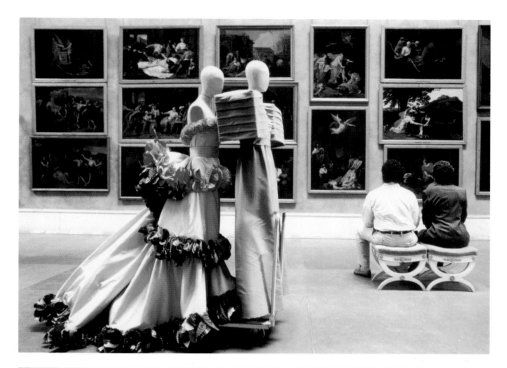

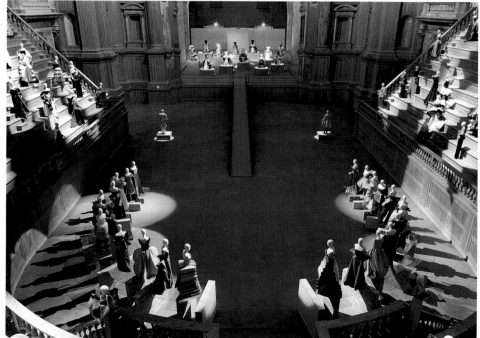

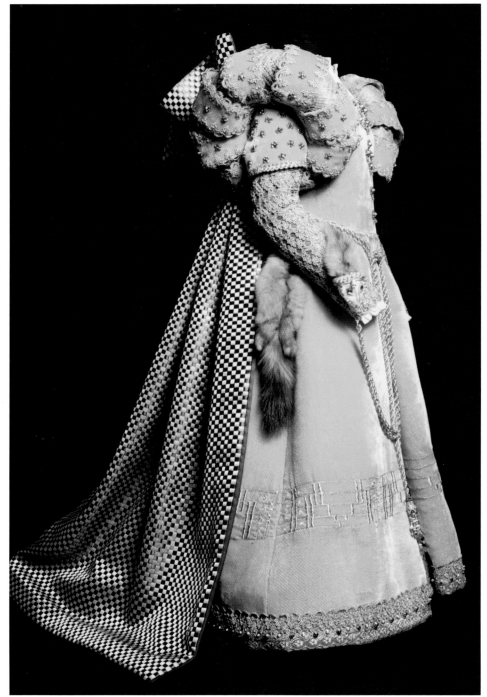

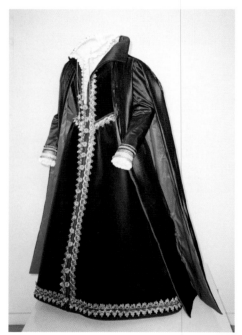

1994-1995, Clothes inspired by Isabella d'Este and Sofonisba Anguissola, monographic exhibition, Kunsthistorisches Museum, Vienna (Capucci Historical Archive).

94

1995, Venice Biennale, XLVI
International Art Exhibition
Cinabro, *original drawing by Capucci*
(Capucci Historical Archive,
photograph by Massimo Listri).

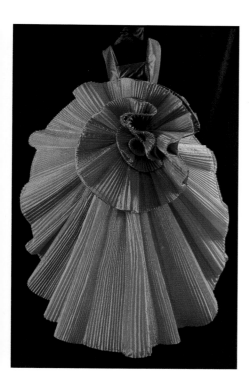

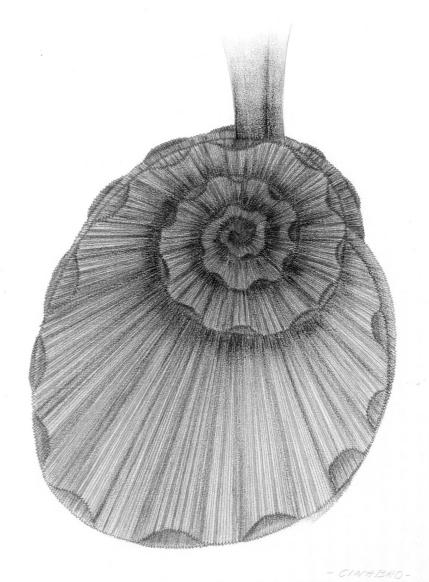

- CINABRO -

Biennale di Venezia 1995

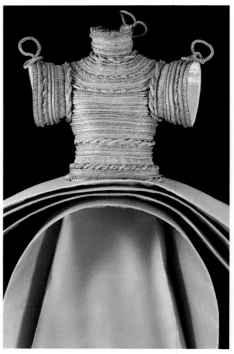

*1995, Venice, Sagenite,
Original drawing by Capucci
and reality
(Capucci Historical Archive,
photograph by Massimo Listri).*

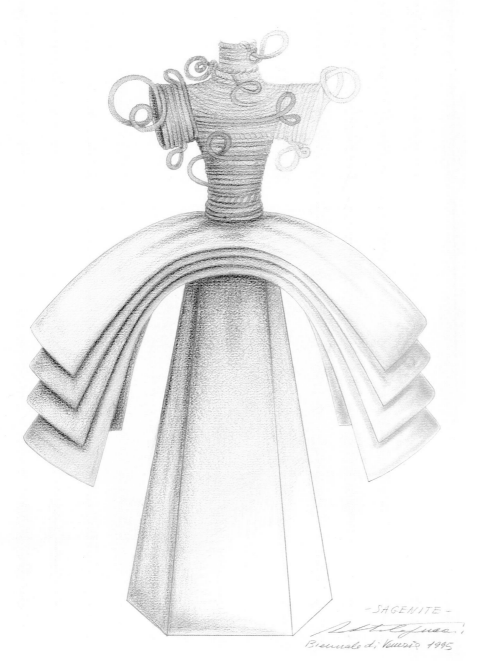

- SAGENITE -

Biennale di Venezia 1995

Roberto Capucci 2000

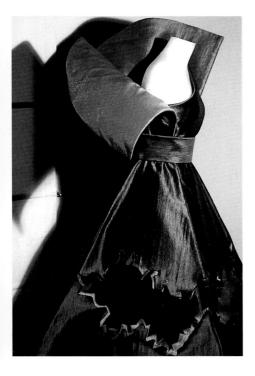

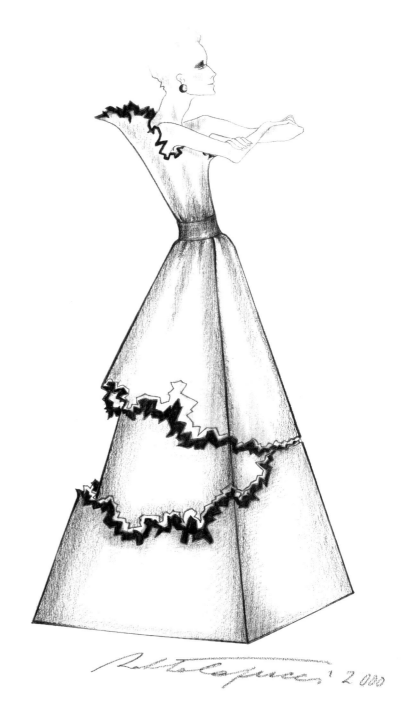

2001, "Roberto Capucci.
Crativität al di là del tempo"
Original drawing by Capucci and
reality made with "Meryl Nexten"
hollow fibre.
(Capucci Historical Archive).

The "Capuccine"

As soon as the unreal inventions of forms and volumes—that travel boxed and protected like works of art and are exhibited in exclusive and surprising settings—leave the cream-coloured atelier in Via Gregoriana close to Trinità dei Monti, they are seen dazzling on noblewomen and young girls in full bloom, Capucci's habitual clients, a sort of fan club, known as the "*Capuccine*". They are high-born, intelligent, determined women who do not so much wear as "interpret" Capucci's clothes as their trains rustle down the marble staircases of the villas of the aristocracy.

The "*Capuccine*" include names like Silvana Mangano, Gloria Swanson, Esther Williams, Marilyn Monroe, Valentina Cortese, Raina Kabaivanska, Marisa Nasi Coop Diatto and Rita Levi Montalcini, and members of the nobility include the Duchess Nicoletta di Serra Capriola and princesses from the Pallavicini, Colonna and Odescalchi families.

The "*Capuccine*" are all "Marvellous women of great determination and character. Often they become my friends, and on certain occasions they lend me their dresses for inclusion in exhibitions," says Capucci. "I could recite hundreds of names. They are women who do not appear in magazines and, like all women with character, do not follow fashion. They find a dress or a colour that suits them and they stick to it. The clothes that they wear are not exactly those that I exhibit or, at least, not always; it is from the displayed articles that I produce the item that the client wants. I follow each one's wishes, I do what I know I have to."

For example, the dress worn by Rita Levi Montalcini during the ceremony at which she received the Nobel Prize. "She is a great scholar, a very particular woman. When she was to receive the Nobel Prize, I dressed her thinking of her figure, slender, very thin, and the significant role that she has. She is not a princess but a person of great importance," Capucci recounts. "I remember I created a long dress with a little bit of train and said to her, 'Professor, you will be the only woman to receive the Nobel among so many men dressed in tails. When you rise, you must be the queen of the evening.' She was very hesitant because she had never worn a long dress nor entered a fashion house but she looked at the train and she said, 'If you have made it for me, I will wear it.' Ever since she returned from the Nobel ceremony, I am the one who dresses her."

Page 98
1970, Silvana Mangano
(Capucci Historical Archive).

1970, Rome, Princess Maria Pia
di Savoia and Capucci in his atelier.

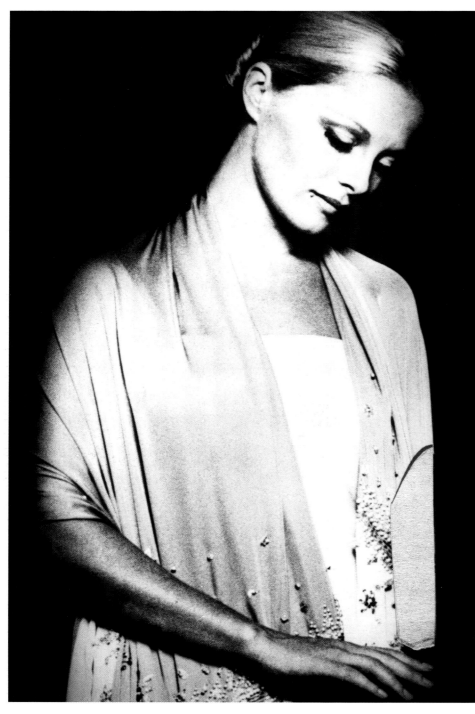

Virna Lisi
(Capucci Historical Archive).

Valentina Cortese
(Photograph by Fiorenzo Niccoli).

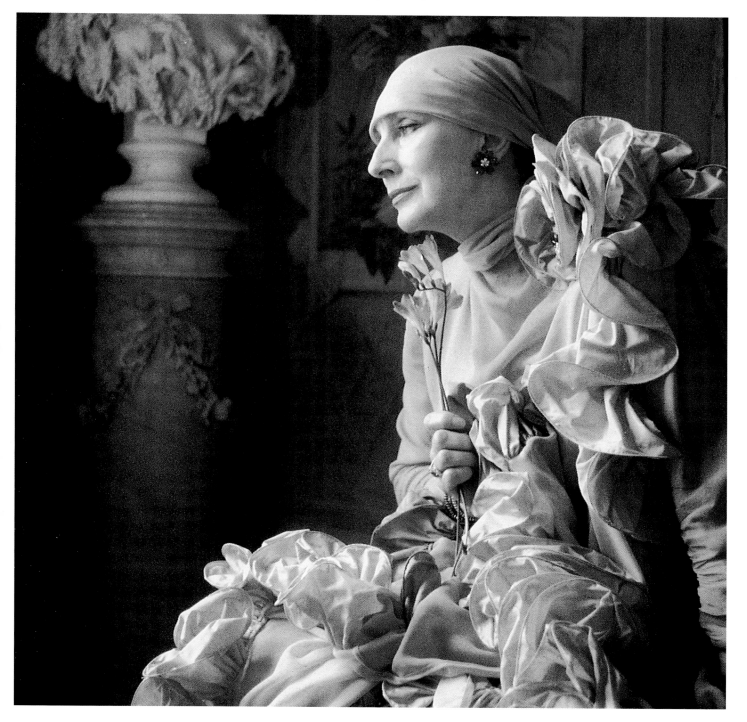

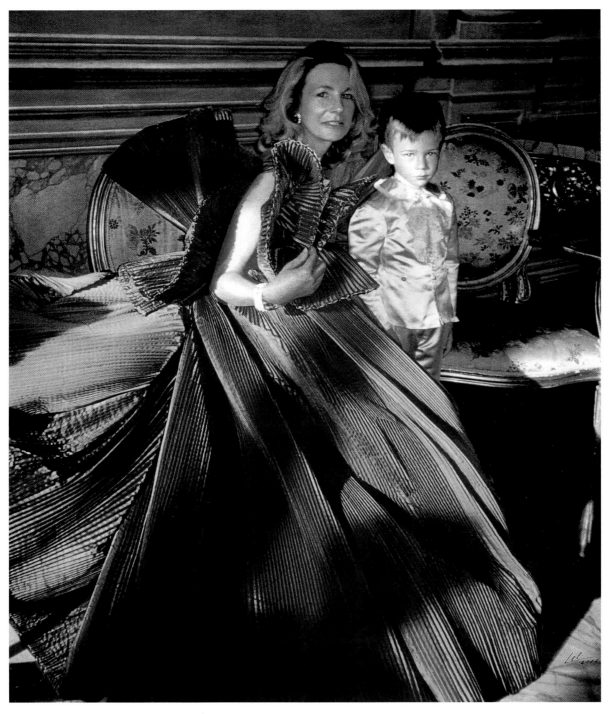

Rome, Princess Jeanne Colonna with her son Filippo
(Photograph by Gianfranco Lely).

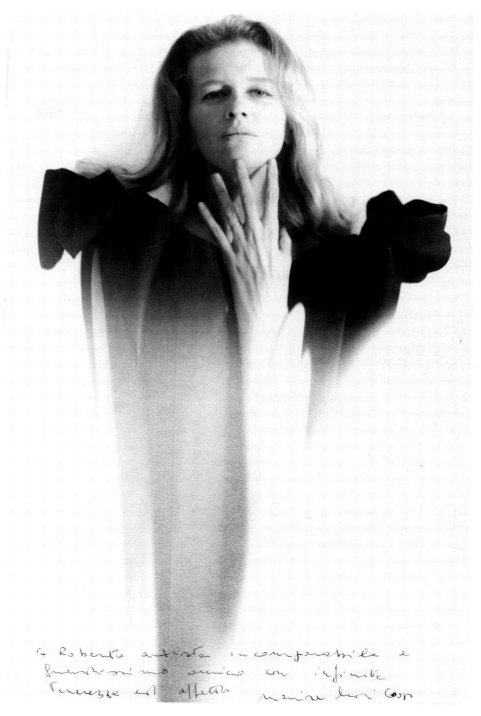

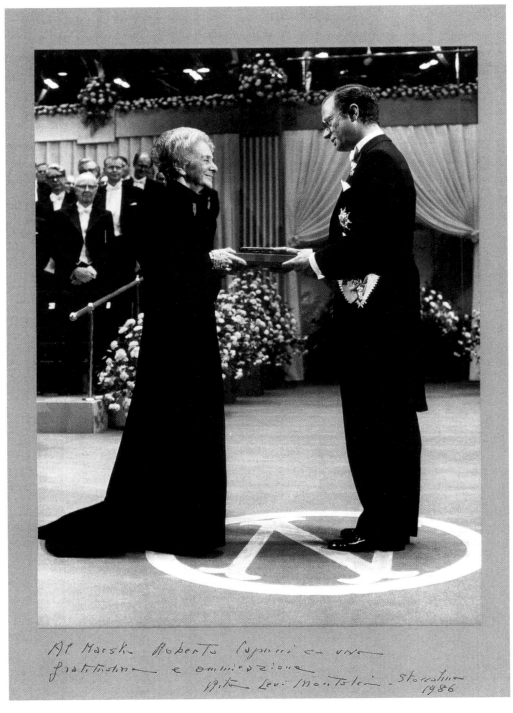

Al Maestro Roberto Capucci con una
gratitudine e ammirazione
Rita Levi Montalcini - Stoccolma
1986

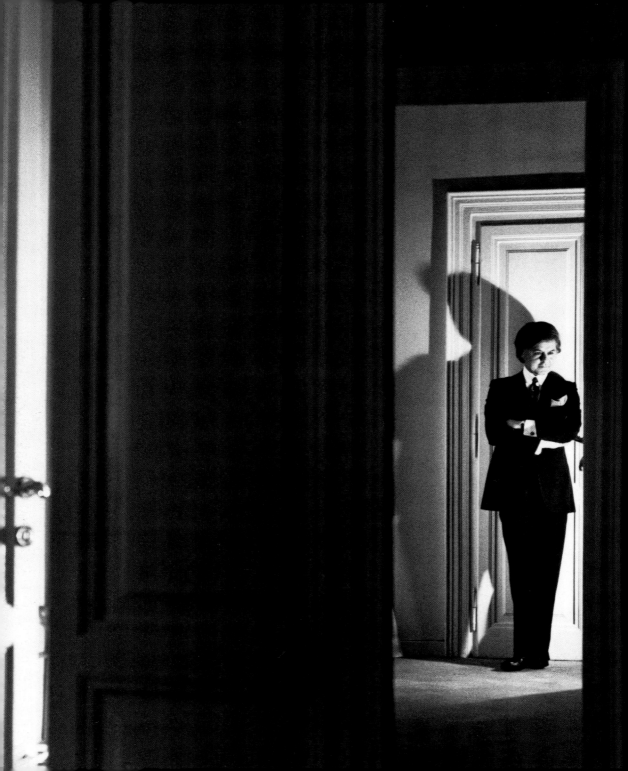

Roberto

"I love life madly: I hate to get old but not for the wrinkles and grey hair. I don't like ageing because I love to see, absorb and 'consume' art and nature, I want to meet well-educated, cultivated people, and I want to see the smiles on people's faces. It's a problem: I am a fan of life."

"What is beauty for me? For me it is something difficult and mysterious. Something to be discovered."

"I need to see beauty but in all its manifestations, whether it is in a painting or a piece of music. Music is the equivalent of a painting or architecture, a leaf, a shadow or a cloud. I am very curious and observe. And then there are all kinds of hidden things to discover."

"I am always in search of an individual solution, a style."

"The famous dress made from concentric circles was inspired by watching the rings created by a stone thrown in water; the luminescent clothes that were presented in the dark in Paris in 1965 followed from watching a procession of the faithful moving slowly forward as they prayed and carrying phosphorescent rosaries in their hands."

"… A bird I saw in South Africa that showed hidden colours when it opened its wings but, when it closed them, was black … The dress with the fan-shaped sections was the result of that sight … even if it turned out to be something completely different."

"First I make lots of drawings, sketches that transpose onto paper my emotions and thoughts and the forms that I see as I travel … Emotions and intuitions inspired by nature and music."

"The way I see and feel art, geometry and aesthetics combine happily. Pascal does not counter *l'ésprit de géometrie* with *l'ésprit de finesse*, he recommends that they should be combined. And that is my religion as an artist or, rather, as an aesthete.
A few geometric lines whose attraction lies in their moderation: this is the starting point for the psychological intuition that leads, like a theorem, to the music of colour or, rather, to the music of many colours."

"One should not be frightened of going beyond the normal limits or of being ironic … If you place limits on yourself, you are fated to remain there all your life."

"Irony is often to be seen in my designs: I may make a certain fold, knot or neckline that does not follow the standards and which go beyond the normal bounds."

"I adopted Schiller's motto: 'If what you do or believe does not please the crowds, try to delight the few. It is a mistake to want to please everyone'."

(Statements by Roberto Capucci, taken from meetings with the designer and from interviews in 1975, 1994 and 1995. The three creations mentioned can be seen on pages 25, 42 and 76).

Page 110
Rome (thanks go to the Villeroy & Boch Archive
Capucci Historical Archive).

Rome, photograph
by G.R. Somerville
(Capucci Historical Archive).

Photograph by G.R. Somerville
(Capucci Historical Archive).

Rome
(Capucci Historical Archive).

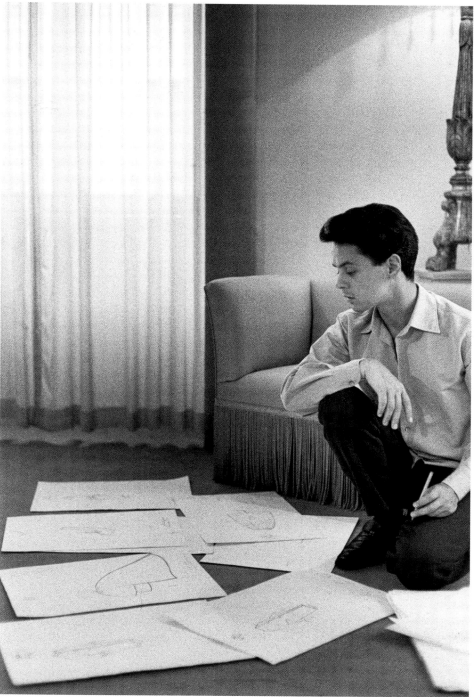

Rome
(Capucci Historical Archive).

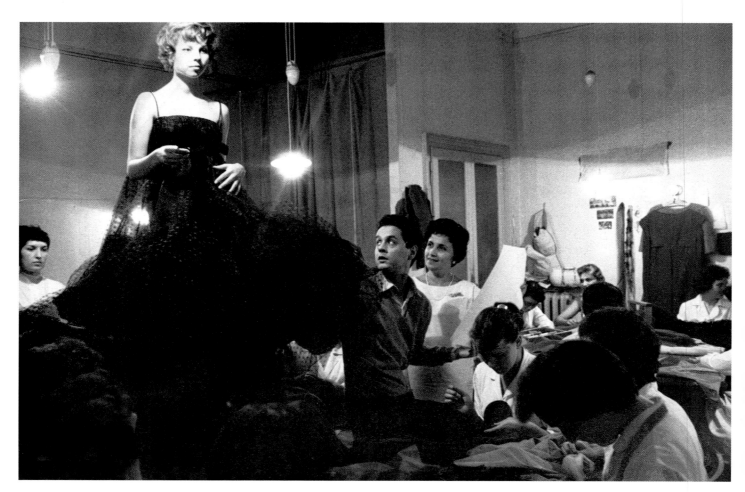

Photograph by Tony Thorimbert
(from "Amica").

Capucci and the Duchess
Simonetta Colonna di Cesarò
(Capucci Historical Archive).

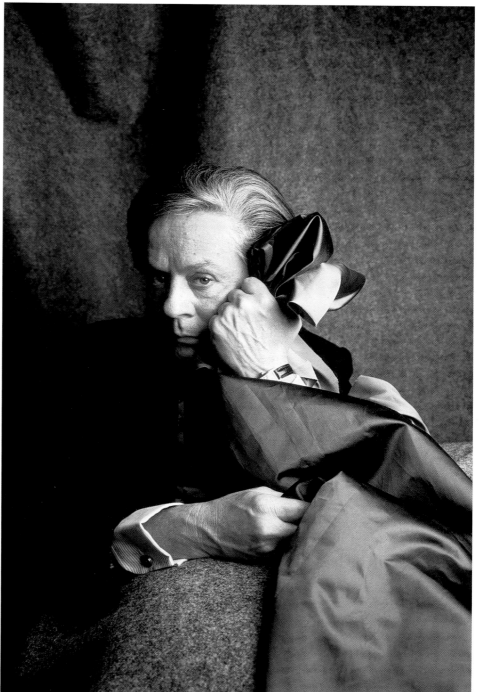

115

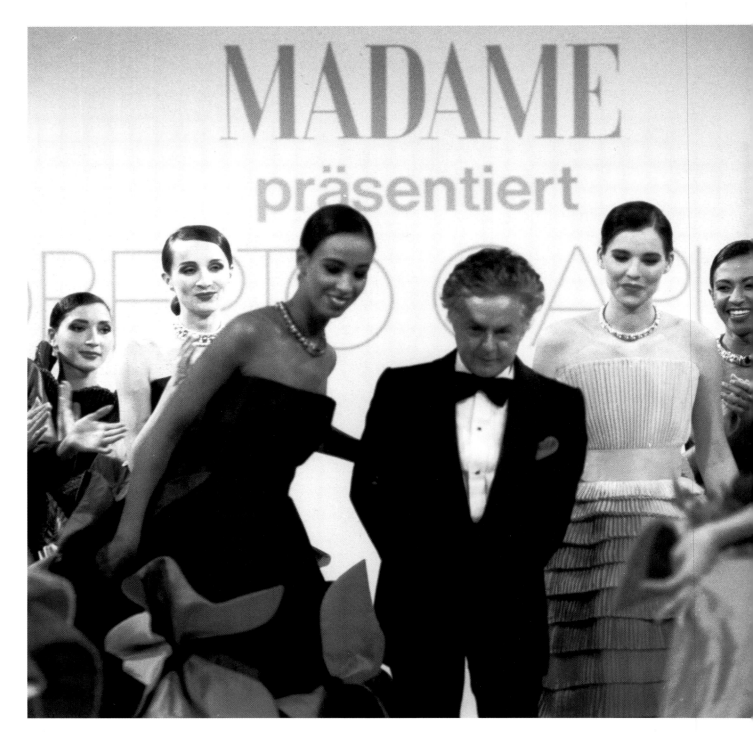

1992, Berlin
(Capucci Historical Archive).

1994, Milan
Capucci, Brera Academician
(Capucci Historical Archive).

1995, Beijing
Capucci and Mrs. Wu Yi, the
Minister of Foreign Trade of the
People's Republic of China
(Capucci Historical Archive).

117

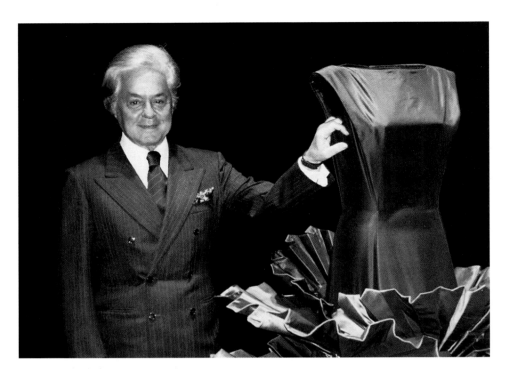

1995, Venice
*Italian pavilion at the Arts Biennale
(Capucci Historical Archive).*

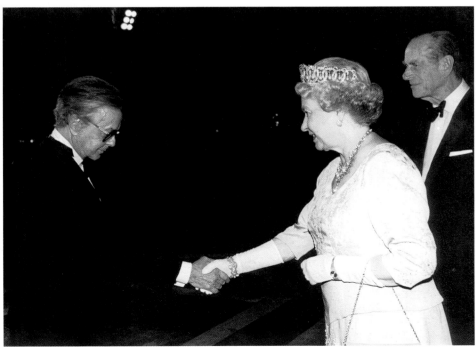

2000, Rome
*Gala dinner at the Quirinale in
honour of Queen Elizabeth II
(Thanks go to the Cerimoniale
del Quirinale, Capucci Historical
Archive).*

1992, Rome
*(Photograph by Angelo Del Canale
from "Famiglia Cristiana," Capucci
Historical Archive).*

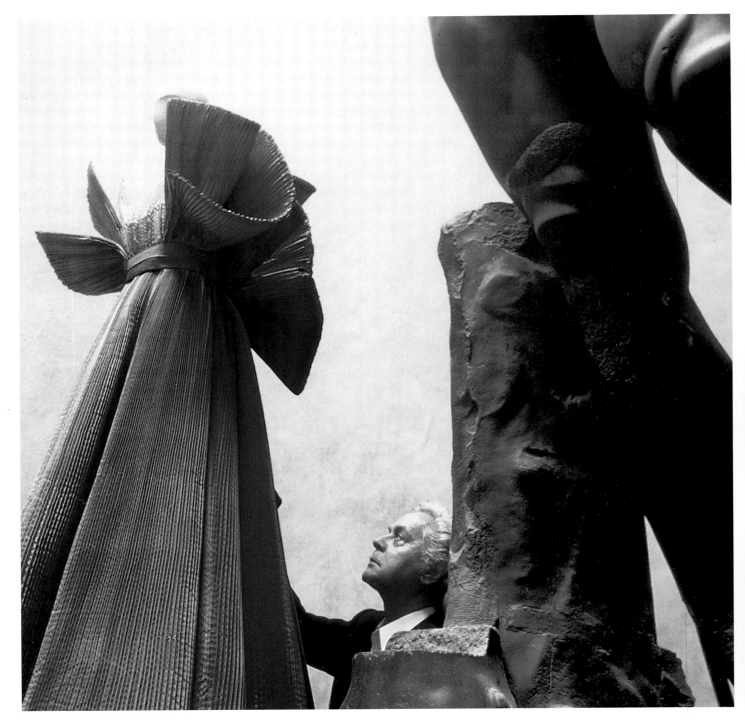

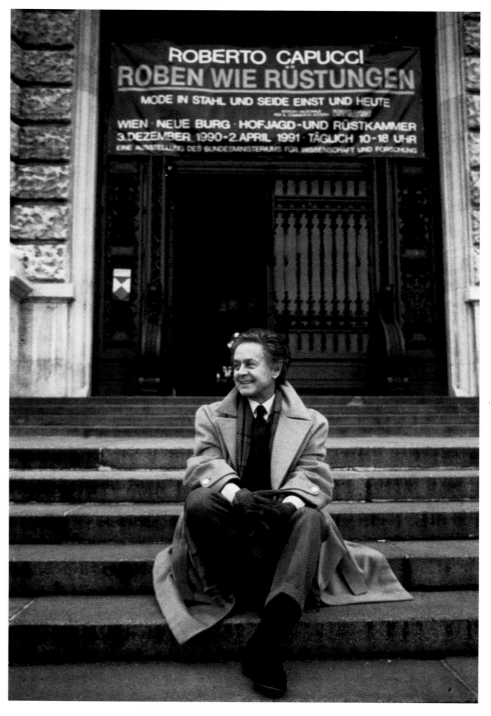

1996, Parma
("Sette" Archive, thanks go to
"Sette, Corriere della Sera" for use
of the photograph).

1990, Vienna
(Photograph by Cristina Ghergo,
Capucci Historical Archive).

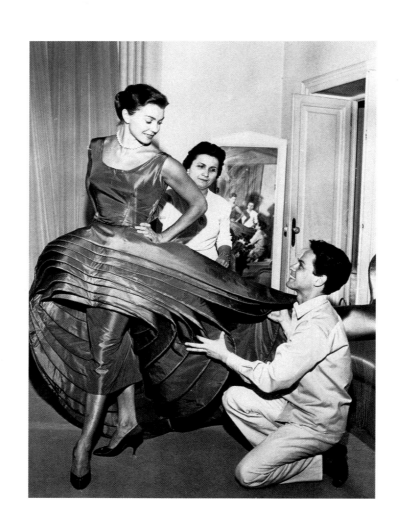

Biographical notes

Roberto Capucci was born in Rome on 2 December 1930.

After finishing art school he studied at the Academy of Fine Arts under teachers like Mazzacurati, Avenali and Libero de Libero. He began his professional career with an atelier in Via Sistina in Rome. In 1951 he was invited to present his designs for the first time in Florence where he caused a stir and aroused a great deal of interest; his entrance into the nascent world of Italian fashion was a great success.

His entire career has been accompanied by success and sensation:
In 1955 he moved to Via Gregoriana.
In 1956 he was acclaimed by the international press as the best designer in Italy; the same year—the sixth since the start of his professional career—he was publicly complimented by Christian Dior.
In 1962 he opened an atelier in Paris where he was welcomed enthusiastically and held in high regard. The French press gave him extensive and positive reviews and Capucci became the first Italian to be asked to lend his name to a perfume.
In 1968 he returned permanently to Italy and settled his creative centre in Via Gregoriana.
In 1970 he collaborated with Pasolini to create the clothes for Silvana Mangano and Terence Stamp in the film *Teorema*; the experience was a moving one for him.
In 1995, Mrs Wu Yi, the Minister of

1956, Rome. Roberto Capucci with Esther Williams.

Foreign Trade of the People's Republic of China, invited him to give lectures on the art of creation at the universities of Beijing, Xi'an and Shanghai. He was also conferred with an Honorary Professorship at the University of Beijing.

In 1996 a scholastic study on the works of Capucci was carried out by the Fashion Analysis laboratory of the Department of General Psychology at the University of Padua and printed by the Paduan publishing company, Imprimitur, under the title *Moda e Arte. Interventi davanti alle opere di Roberto Capucci.*

The Collections

With the passage of time, Capucci was increasingly taken by the desire for experimentation but he felt the need to work in complete independence and freedom.

In 1980 he left the institutionalised structures of the fashion world with the intention of producing just one collection a year and of presenting it on each occasion in a different city, "the one that is willing to welcome me," he said. He wanted each collection to be like an exhibition, similar to a one-man show by an artist.

Since that time, his collections have been presented in:
Milan at the Palazzo Visconti, October 1982;

Tokyo in the Sumitomo Corporation, November 1983;
Paris at the Italian Embassy, January 1984;
New York at the National Guard Armory, May 1985;
Rome at the Palazzo Venezia Museum, January 1987;
Rome in the National Gallery of Modern Art, January 1989;
Munich at the Madame Fashion Show, March 1989;
Berlin, at the Schauspielhaus, November 1992, the show was accompanied by music from the Kammerensemble des Berliner Sinfonie Orchesters;
Vienna, at Schonbrunn Castle, April 1994;
Graz, Eggenburg Castle, April 1994.

Prizes and Honours
Naples, 1954, "Festival of Fashion and the Italian Textile Industry." The Mayor of Naples presented him with the Diploma of Honour awarded by the exhibition organising committee.
Turin, 1955, "IX presentation of Italian High Fashion," the Italian Clothing Fashion committee awarded him the medal of honour.
Venice, 1956, Palazzo Grassi. Capucci was awarded the Venice gold medal at the first International Clothing Collection, "Fashion in Contemporary Costume."
Boston, 1958, he won the Fashion Oscar with the design *Linea a scatola*. The prize, instituted by Filene's of Boston, was awarded to an Italian for the first time.
Milan, 1961, He won the fashion critics' prize for *Linea a scatola*.
Capri, 1973, Maremoda Capri. He was presented with the gold Tiberius award.
Vienna, 1991, Kunsthistoriches Museum. He was made a honourable member of the

Austrian Figurative Arts Society (Kunstlerhaus) for the quality of his work in the field of Design.
Milan, 1994, Brera Academy. He was appointed and Academician of Brera by the Academy of Fine Arts.
Beijing, 1995, University of Textiles and Clothing. He was made an Honorary Professor by the Rector of the University.
Ravello, 30 June 1998. He was awarded a Recognition for Creative Production by the Organisational Sciences Specialisation School S3-Studium di Roma. The teaching staff and students decide the recipient of the award and each year goes to the greatest scholars, businesspeople or managers who excel in the field of creativity.

Homage to Callas
Capucci worked with the theatre for the first time in 1986 when he was asked by the Verona Arena to design and produce the costumes of the priestesses in Bellini's *Norma* in the production *Omaggio alla Callas*.
Some of these costumes are now displayed in museums in Italy and abroad:
Munich, Münchener Stadtmuseum.
London, Victoria and Albert Museum and Covent Garden Theatre.
Milan, Sforzesco Castle Museum.
Florence, Pitti Palace Costume Gallery.
Venice, permanent display in the Biennale Archive.

Costumes in Permanent Museum Collections
Florence, Pitti Palace, Costume Gallery.
Venice, Fortuny Museum, *La Donna Gioiello* in the exhibition "Dogi della moda", 1984.
London, Victoria and Albert Museum.
Vienna, Kuntsthistorisches Museum.

Solo Exhibitions

Florence, January-February 1990, Palazzo Strozzi, "Roberto Capucci, l'Arte della Moda – Volume, Colore, Metodo."
188 articles designed from the Fifties to the Nineties.
Catalogue published by Fabbri Editori.
Munich, April-December 1990, Stadtmuseum, "Roberto Capucci, l'Arte della Moda – Volume, Colore, Metodo".
Second showing of the exhibition at Palazzo Strozzi. 150 articles designed from the Fifties to the Nineties.
Catalogue published by Fabbri Editori, translated into German.
Vienna, December-April 1991, Kunsthistorisches Museum, "Roberto Capucci, Roben wie Rustungen", 80 articles designed from the Fifties to the Nineties with 80 suits of fifteenth-century parade armour and 15 display uniforms from the eighteenth century that belonged to the imperial Hapsburg family and are now part of the museum collection. Roberto Capucci was made an Honorary Member of the Kunstlerhaus and awarded the decoration that had only previously been bestowed upon Miró, Tapies and Mondrian.
Catalogue published by the museum.
Cernobbio, March 1993, Villa d'Este. Exhibition of 50 articles including 35 presented in Berlin and previously unseen in Italy, and 15 from Capucci's archive, plus drawings and historical documents.
Rome, March-April 1994, Palazzo delle Esposizioni, "Roberto Capucci. I percorsi della creatività", exhibition of archived articles and drawings of dresses, some produced, others not. New catalogue by Fabbri Editori.
Vienna, April-June 1994, Schonbrunn Castle, exhibition of archived articles and drawings of dresses, some produced, others not.

Montefalco (Perugia, Italy), 1994, for the first time Capucci's archived articles were displayed with other works of art, in this case fifteenth-century paintings by Benozzo Gozzoli and Perugino.
Beijing, February 1995, Mrs Wu Yi, the Minister of Foreign Trade of the People's Republic of China, invited Roberto Capucci to present his creations to celebrate the first edition of "La Via di Marco Polo."
Luxembourg, May-June 1996, to mark the six month Italian presidency of the European Union, Capucci was invited by the Italian Cultural Institute of the Embassy to display the 12 articles exhibited at the Venice Biennale in June 1995 in the Luxembourg Municipal Palace.
Parma, June-September 1996, Palazzo Pilotta, "Roberto Capucci al Teatro Farnese – In difesa della bellezza". 153 articles designed from the Fifties to the Nineties plus drawings of dresses, some produced, others not and technical drawings with samples of materials.
Milan, February 1999, Palazzo Bagatti-Valsecchi, "I disegni mai realizzati di Roberto Capucci." 150 original illustrations by Roberto Capucci using various techniques; some of the designs were produced and others not. Also displayed was the sculptural dress exhibited at the Lisbon Expo in 1998.
Viterbo, "Quando la Moda è Arte." Invited by the Municipality, Capucci exhibited 12 articles in the Palazzo dei Priori created for the centenary of the Venice Biennale.
Rome, 13-28 July 2000, Palazzo Colonna, "L'Elogio della Bellezza." 70 sculptural dresses exhibited in the palace's Gallery.
France, 22 October 2000, Château de

Chambord, solo exhibition organised by the Latin Union and the National Monuments Centre. 62 sculptural dresses displayed.
Venice, 13-27 February 2001, Tese Cinquecentesche all'Arsenale, "Roberto Capucci. Creatività al di là del tempo". 48 sculptural dresses displayed and 100 videos.

Collective Exhibitions

New York, January 1986, Columbia University, "Sixty years of Italian cultural life," organised by the Enciclopedia Italiana Treccani. One sculptural dress from the 1985 collection was exhibited.
Munich, July 1986, Münchener Stadtmuseum, "Varieté de la Mode 1786/1986". 3 articles from the 1965 and 1985 collections were exhibited. Catalogue of the exhibition.
New York, April 1987, Fashion Institute of Technology, "Fashion and Surrealism." 3 articles from the 1982-1983 collection.
London, December 1987, Foreign Trade Institute to mark the visit of President Cossiga, 12 articles from the 1987 collection.
Rome, December 1987, museum in Palazzo Venezia, "Sixty years of Italian cultural life," organised by the Enciclopedia Italiana Treccani. One sculptural dress from the 1985 collection was exhibited.
London, June 1988, Victoria and Albert Museum, "Fashion and Surrealism." 3 articles from the 1982-1983 collection.
Cologne, November 1990, Museum für Angewandte Kunst, "200 Jahre Mode: Kleider vom Rokoko bis Heute." 2 articles from the 1956 and 1982 collections were exhibited for two years to celebrate the opening of the new Fashion and Costume

department. Catalogue of the exhibition.
Erfurt (Thuringia) June-August 1991, "Configura 1 Kunst in Europa," Triennial that replaced the Quadrennial of the Socialist era. One of 350 European artists from all fields, Roberto Capucci exhibited one of his textile sculptures from 1987; it was the only work made from textiles. Catalogue of the exhibition.
Paris, April-July 1993, Hotel de la Monnaye, "Regards sur la Femme." Art and sculpture, Picasso, H. Moore, Balthus, Giocometti, André Masson and others. 15 sculptural dresses in textiles from Capucci's archive plus permanent articles in the archive of the Kunsthistorisches Museum. Roberto Capucci's works were the only ones made from textiles.
Vienna, February-May 1994, Kunsthistorisches Museum, "The first lady of the world – Isabella d'Este." Roberto Capucci's contribution was a free interpretation of a dress recreated from contemporary historical sources.
New York, October 1994, Guggenheim Museum, "Italian Metamorphosia," articles from Fifties and Sixties from Capucci's archive. Catalogue of the exhibition.
Vienna, January-April 1995, Kunsthistorisches Museum, "The first woman painter – Sofonisba Anguissola (Erste Malerin der Reneissance)." Roberto Capucci's contribution was a free interpretation of a dress recreated from contemporary historical sources.
Venice, June 1995, Biennale. Roberto Capucci was one of the twenty artists invited to participate in the Italian section to mark the centenary of the event. He contributed 12 specially designed sculptural dresses.

Lisbon, May 1998, World Expo. Roberto Capucci was invited by the Italian Foreign Office to create a textile sculptural dress inspired by the title of the event, "The Ocean, the future of the Seas" to be exhibited in the Italian pavilion. His was the only work made from textiles.

London, October 1998, Hayward Gallery, "Addressing the Century – One hundred years of Fashion and Art." 2 articles were exhibited.

Wolfsburg, March 1999, Kunst Museum, "Kunst und Mode im 20° Jahrhundert." Same articles as the Hayward Gallery exhibition "Addressing the Century" above.

Bari, 15 April – 31 August 2000, "Le ali di Dio: Messaggeri e guerrieri alati fra Oriente e Occidente." 5 articles exhibited at the Castello Svevo inspired by angels together with paintings by Botticelli, Domenichino, Guido Reni and others. The same exhibition went to the Abaye aux Dames in Caen in France from 29 September – 31 December.

Milan, 26 April 2000, Palazzo della Permanente, 2 articles inspired by nature displayed in the exhibition "A misura di ambiente – Cantico 2000." The exhibition included works by artists, architects such as Norman Foster, and famous examples of Land Art.

Rome, 21 September 2000, charity fashion show for the women of Andhra Pradesh, India, preceded by a presentation of historical Indian costumes.

Pages 128-131
1998, Rome
Production of the dress displayed
at the Lisbon Expo entitled
The ocean, the future of the seas
(Photograph by Fiorenzo Niccoli).

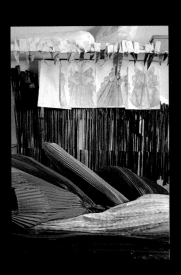

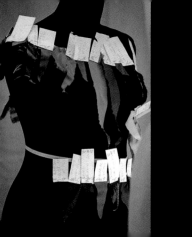

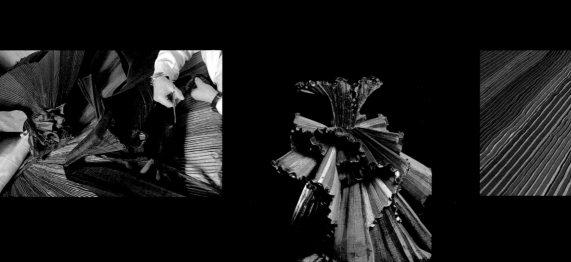